D1468242

CONTEMPORARY ART IN THE LIGHT OF HISTORY

by

ERWIN ROSENTHAL

Introduction by Lance Esplund
A Biographical Note by Julia Rosenthal

ARCADE PUBLISHING • NEW YORK

Contents

Plates I–XXV follow page 100.

Foreword

This collection of three essays is aimed at throwing some light upon the controversial field of modern art.

The first essay attempts to provide an element of historical perspective, which gives the necessary detachment and objectivity, and helps avoid a great many pernicious misconceptions about modern art. In the mid sixties, abstract art reached a definite stage in its development, and 1964 could be called the year of crisis. The following study is to be understood from this viewpoint.

The second chapter approaches the subject somewhat more directly by exploring the relationship between art and technology. The importance of optical and kinetic elements for contemporary art could not be clearly determined around the mid century. Only in 1966/67 was it possible fully to appreciate their significance; therefore this study is to be seen from the perspective of those years.

The third study, "Art Theories and Manifestos", gives a broad survey of the history of aesthetics from antiquity to the middle of the twentieth century. It endeavours to leave the reader with a theoretical framework by tracing the development of aesthetic and critical theories which led to contemporary trends in art.

These studies do not try to set up axiomatic historical rules; rather they attempt to envisage the history of art in terms of perpetual principles. As a sort of modest guide this small book, stressing the same creative impulses for ancient as well as contemporary art, may help to overcome the widespread bewilderment about modern art. The mystery of the growth

and change of styles is deeply embedded in the history and mind of man. All the different and even contradictory expressions and achievements in the figurative arts are but reflections of the eternal problem of transferring aesthetic sensibilities into images, forms, colours, or pure symbols. Thus these reflections could be understood as studies in continuity.

E. R.

Introduction

Erwin Rosenthal's book *Contemporary Art in the Light of History* is as relevant and important today as it was when it was first published more than forty years ago. One might ask how Rosenthal's text—written before the advent of the Internet and social media; before the Culture Wars and the persecution of the Chinese dissident artist Ai Weiwei; before the fall of the Berlin Wall and the attacks of 9/11—could have any real bearing on art in our contemporary world. The answer is that Rosenthal, who is as engaged here with what artists make as he is with artists' motivations, has anticipated not our historical milestones and technological advances but, rather, our ongoing desire to understand what drives artists individually and our culture collectively.

As in Arnold Hauser's large multivolume *The Social History of Art*, Rosenthal's compact text considers art in relation to other fields—literature, science, technology, music, philosophy, psychology, politics, and spirituality. He takes into account the importance of intellect and emotion; Romantic and Classical tendencies; mimesis and fantasia; insanity, reason, rebellion, shock, and the grotesque; the dual poles of representation and abstraction; and the metaphysical origins of art.

Rosenthal sees art not as progressing but, rather, as always relevant, no matter when or where it was made. In the Foreword to *Contemporary Art in the Light of History*, he writes that his studies "attempt to envisage the history of art in terms of perpetual principles. As a sort of modest guide this small book, stressing the same creative impulses for ancient as well as contemporary art, may help to overcome the widespread bewilderment about modern art."

To that end, Rosenthal is concerned with putting contemporary art in the context of the art of the past. Writing in clear, limber prose, he makes leaps through history and across disciplines. His great range is underscored by the simplicity of his language and the matter-of-factness of his conclusions. To read this book is to participate with the author as he wrestles with challenging ideas, paradoxes, and matters of spirit. When Rosenthal, discussing the necessary tension between Apollonian and Dionysian tendencies, writes that "the interaction of theory and free inspiration is one of the ultimate secrets of the artist," we are brought closer to art through the acceptance of its mystery.

Interested not in influence but in analogy, which Rosenthal refers to as "related psychological climates," the author lays out art-historical "links in a chain." He draws connections and parallels among artists' attitudes and styles in ancient Egypt, antiquity, the Medieval, Renaissance, Baroque, and Modern eras. "All the different and even contradictory expressions and achievements in the figurative arts," Rosenthal writes, "are but reflections of the eternal problem of transferring aesthetic sensibilities into images, forms, colours, or pure symbols."

Rosenthal begins with the art of his present. He recognizes that Mannerism, Romanticism, Surrealism, and Abstract Expressionism—still somewhat dominant in 1971— all have their roots in the anti-classical tradition of antiquity, in "the oriental occultists and mystics—in whose work Orphic dogma, Hebrew philosophy, and the rites and cults of Ancient Egypt lingered on." Rosenthal connects the objectivity, purity and depersonalization—the Cartesian spirit—of Fra Angelico to

analogous aspects in Piero della Francesca, Raphael, Poussin, Cézanne, Mondrian, and the Op Art movement. Paying close attention, for example, to the Op Artist Bridget Riley, he aligns her and other contemporary artists' work with the perceptually based science and art of Leonardo, the philosophy of Blaise Pascal, moving sculptures in Renaissance gardens, the free line of Art Nouveau and Kandinsky, the geometry of Naum Gabo, Jean Arp, and Constantin Brancusi, and the "colour clavicembalo"—"a keyboard instrument which could be combined with optical effects"—invented by the 16th-century Italian painter Arcimboldo.

But Rosenthal also strives to keep art separate and sacred. He acknowledges that "art is woven into the dynamic pattern of history," but he also recognizes that artists are individuals nourished primarily by other artists and works of art. He cautions against the influence of writers, philosophers, and financiers on visual artists, and he repeatedly emphasizes that all major artistic innovations would have happened despite the world outside art. "The social history of an epoch may have distinct effects on its art," Rosenthal writes, "but even the richest patron would not have had any substantial influence on the creative genius of the artists."

Rosenthal, a man of his time (he died at age ninety-two in 1981), explores his subject up through the art of the late 1960s, but he does not place greater importance or emphasis on the art of his own time than on the art of centuries past. As an objective voice for art and artists, he is not afraid to make aesthetic judgments, to be critical, or to take sides. Rosenthal is concerned in *Contemporary Art in the Light of*

History with identifying a value system in art that stands the test of time. Discussing the "fanatical anti-intellectualism . . . pomp, demagoguery, and arrogance" of Dada and Surrealism, Rosenthal observes that "Breton was a gifted author and poet, and yet one may wonder whether so much intellectual energy had ever been wasted before in trying to prove that the intellect is both useless and dangerous for the creative artist." In our contemporary art world, these observations perhaps have more relevance today than they did forty years ago.

In this short book, this "modest guide," Rosenthal has created a classic introductory text on modern and twentieth-century art up to 1971. His "modest guide" does nothing less than accompany us into the mysteries of contemporary art past, present, and future.

<div align="right">

Lance Esplund
November 2012

</div>

TO

WILLIAM W. MELNITZ

I

Contemporary Art
in the Light of
History

The history of art is full of controversies, many of which have served valuable functions for both artist and audience. The debate concerning contemporary visual art has been especially heated, however, and in the flurry of charge and counter-charge it is often hard for the spectator to find the proper relation to the work under discussion. One way, I believe, of avoiding many of the misconceptions which stand in the way of an appreciation of contemporary art is to consider it within its historical framework, though one needs to proceed with caution since a number of widely accepted historical generali-zations have obscured important issues. It is very misleading, for example, to think of the acme of Greek art as a necessary consequence of the "Golden Age" of Pericles. It is equally deceptive to link the flourishing of Florentine Renaissance art with the political and economic boom that Florence expe-rienced under the Medici family. The social history of an epoch may have distinct effects on its art, but even the richest patron would not have had any substantial influence on the creative genius of the artists. Moreover, history offers enough examples of artists whose genius was not recognized by their contemporaries, and who were forced to go hungry and die in poverty. The work of such artists finds praise and general acclaim only at a considerably later date. And who, in this connection, shall decide the merit of the individual artists? Who, for example, could ever state definitely that Botticelli was a greater artist than Pontormo, or vice versa? Individuals, as well as whole generations, may judge differently. The fact which we are ultimately faced with is that art, and its historical

development, has roots which go too deep to be fully ex-plained by rational means.

In these circumstances, how is it possible to approach contemporary art as a part of history? What criteria can we apply to evaluate the works of contemporary artists with some degree of reliability and justice? Does not the sharply divided opinion of the public make objectivity impossible?

The key lies first of all in discarding such rigid and sub-jective terms as good/bad, beautiful/ugly, and then proceed-ing in the cautious and unbiased manner of the historian, always bearing in mind that an historical approach is but a useful tool adopted pragmatically, not a means of formulating ultimate answers.

A brief survey of the history of ideas, then, may help us to understand modern art. We must go back to 18th-century English philosophy and to the French and German Romantic theorists and poets. It was there that the concept of "genius" was born, the idea that exceptionally gifted individuals should be allowed every freedom so that they might become god-like creators. Poets and writers alike imagined totally subjective works of art, poems consisting of beautiful words and sounds but without coherence or meaning. But art and poetry were not ready to take up such a challenge, and it was only in the related psychological climate of the late 19th century that the French Symbolists began to realize the dreams of the Romantics. As late as 1900, painters and sculptors began to follow in the same direction and to abandon all traditions in a powerful revolution. This period saw the birth of abstrac-tion and the beginning of the battle for "absolute" values. The full impact was felt when Matisse, in 1905, led the Fauves in breaking all the traditional rules of form and colour, and

when Picasso painted "Les Demoiselles d'Avignon" in 1907, thereby denying the criterion of beauty in art that had been accepted for centuries.

What was it that unleashed and directed these momentous forces? Simply referring to historical facts does not unlock the riddle, yet art *is* woven into the dynamic pattern of history. Changes in styles, breaks with tradition, and startling innovations may be most fruitfully considered as symptoms of the changing emotional climate. But what does the emotional climate consist of? What are the factors that bring about such tremendous changes and how can we single out and describe those factors which lead to quite new forms of expression in art? I think Gertrude Stein, without clinging to any profound philosophy or psychology, found very simple words which are rather helpful: "People really do not change from one generation to another, as far back as we know history people are about the same as they were ... indeed nothing changes from one generation to another except the things *seen*. And the things seen make the generation ... one of *seeing* and *being seen*."

One could say that beneath the surface stream of the historical process flows a subtler, and perhaps ultimately more significant, current of change; a gradual evolution in ways of perceiving, and hence of being. Ways of seeing, ways of feeling, ways of apprehending the subtler aspects of reality are continually changing, and though the more positivistically inclined dislike such un-empirical concepts, poets and artists have always been more attuned to the psychic atmosphere of the age. Miss Stein speaks of this phenomenon as the "composition" of an epoch, and this is more or less what we call the psychological climate. Obviously the response of the

artists to the changes of such a climate is scarcely unified; in every period there is an elite of pioneers who insist upon riding the crest of the wave of the future, while their more conservative contemporaries still have an emotional commitment to the norms and ideals of the preceding period. It should be remembered, of course, that "new" is not a priori indicative of high quality, and not being avant-garde is not necessarily a flaw, as some of the more snobbish would have us believe. Furthermore, one should bear in mind that only a minority of creative artists are sensitive to the oscillations which are in the air and which cause fundamental changes in expression and in style, though a permanently significant breakthrough by the avant-garde usually draws the main body of artists in the direction it has taken, sooner or later.

The new conceptions of such revolutionary artists as Matisse and Picasso, then, are more profitably viewed as manifestations of the continually changing psychological structure of history, rather than as the frivolous indulgence of personal whim, or as an irresponsible attempt to shock the bourgeoisie. Still it is understandable that mistrust, confusion, and bewilderment are the first responses to something completely new and that at such moments the critical onlooker wonders what art really is. A definition of art is, of course, much more difficult than would appear at first glance. Consider, for example, the legal battles that have been fought over precisely this point. Twenty-five years ago one of Brancusi's bronze birds arrived in New York. It was held up for two years by the United States Customs officials because they were unable to decide whether this sculpture was taxable as a piece of metal or could be entered duty-free as a work of art. And while the sculpture was being held in limbo for want of an adequate definition of

its status, prominent artists and critics were continually assailed by the questions: Is this a work of art? What is art?

Finding an answer to these questions is extremely difficult because more than the works themselves is involved. Much depends on the beholder, and everyone's artistic judgment is biased to some extent. We are influenced by what we have seen and learnt, our aesthetic judgement has been formed by those works of art which have been held up to us as examples of "good" or "great" art, and it is scarcely surprising that we feel a sense of shock and anger when we are unable to relate a new mode of expression to our past experience, and to the image of excellence which has been created in our minds. Unfortunately, there are many who, finding it all too strange, will take the easy way out by simply rejecting a new form of art without making any effort to understand it.

Art, however, has never been completely dependent for its development or its life on the reactions of the critics and the public. Theorists or groups of literati may formulate ideas about a new style, but in the end it is the artist, driven by his own inner impulses, who decides what the visual image will be. For example, the Classicism of the "Grand Siècle" was not the mere result of the rules of the Roman and French Academies, although there existed between the artists and the Academies a mutual exchange of principles and ideas. Guillaume Apollinaire propagated, but did not create, Cubism in the period around 1910, and it is hardly likely that Picasso would have taken another direction if he had never discussed certain problems with the poet. Similarly, it is doubtful whether Max Ernst would have developed differently as an artist had he not come under the influence of Breton's theories of Surrealism. Even where there is an evident kinship between the

figurative arts and literature, it is wiser to treat the resemblance in terms of analogy rather than in terms of influence.

As mentioned before, critics at the present time have a tendency to react sharply to contemporary art: there are, on the one hand, those who see the dawning of a brilliant new period of art, and those who see in current trends the end of art itself. Lest we succumb to a rather pervasive tendency to over-react, it is well to bear in mind that no art period has escaped critical conflict, sometimes rather genteel but often bitter and sustained. Consider, for instance, a comparison between two epochs that are currently considered major periods of artistic achievement: the medieval art of Sicily, Rome, and Venice, as represented by mosaics and mural paintings; and fresco painting as developed by Raphael in Rome in the early 16th century. Imagine one of the painters of the former period stepping somehow across the boundaries of time to confront Raphael's fresco "Disputa" in the Vatican [Fig. 1]. Perhaps if he had been graced with a fair amount of open-mindedness and aesthetic flexibility, he would grudgingly acknowledge that a certain amount of progress had taken place. It is rather likely, though, that he would turn away in shock and indignation, for everything that had been meaningful for him would have disappeared. His artistic world had been a highly stylized one, aloof and remote from the earthly and the realistic [Fig. 2]. Here, however, he is exposed to an extreme form of naturalism, to hundreds of details which he would have suppressed as contrary to his ideal of art.

As another example, consider the situation of an art lover born in the latter half of the 15th century in Florence. As a young man he would have developed his ideas on painting from the art of Botticelli [Fig. 4] and Ghirlandaio. In his

sixties, however, he would have been confronted with the Florentine Mannerists, with such paintings as Pontormo's "Christ's Deposition from the Cross" [Fig. 3]. Certainly this must have been a bewildering experience! The effect on the onlooker must have been like viewing a theatrical performance—with figures presented in violent, dramatic postures and gestures and illuminated by an unfamiliar colour scheme reminiscent of artificial stage lighting. And what about his reaction to Michelangelo's "Holy Family", painted immediately after the turn of the century? Was this peasant woman in her strange distorted pose a Madonna at all? The conventional landscape background had disappeared and instead the Holy Family with St. John was placed in front of a group of nude figures whose relation to Mary and Joseph is hard to interpret. Michelangelo's art radiated a tremendous energy which drastically changed the approach to the visual arts, and the sheer power of his genius must have perplexed many of his contemporaries. One cannot help but wonder about the feelings of the spectators who, on Christmas Day 1541, were confronted with the gigantic and strangely contorted figures of the "Last Judgment" in the Sistine Chapel [Fig. 5]. They may have thought that art could go no further on this particular path—a thought also expressed by some critics in relation to modern abstract art. In fact the rejection of the fresco started with the famous and rather brutal letter sent to Michelangelo by Pietro Aretino. The scandal ended fifteen years later with an order of the Pope to have parts of the mural repainted by a pupil of Michelangelo's.

It is also important, I think, to bear in mind that the reputations of certain artists, now considered great leaders of their time, have fluctuated very much in the past. The appraisal of

Rembrandt and Raphael, for example, has gone through a remarkable series of ups and downs. Rembrandt's popularity had already begun to decline in his lifetime. For about fifty years after his death Rembrandt's paintings commanded scandalously paltry sums. In the mid 18th century, however, critical judgement of his work began the ascent to its present lofty peak. The early Flemish, Dutch, and German painters whom we admire so much, suffered a similar fate. They were not rescued from the virtual oblivion to which they had been consigned until the Romantic period. As a matter of fact, their rediscovery was not so much an aesthetic recognition as a result of the Romantics' penchant for glorifying past epochs of Northern art and literature. Despite this reappraisal and new-found admiration, though, the brothers Boisseré, the greatest collectors of Northern art, met with very little competition in their search for masterpieces from these early periods. And when, in 1827, Bavaria's art-loving king, Ludwig I, purchased the collection, the Prussian Government was the only other serious contender.

In presenting these examples I have tried to show some of the difficulties inherent in the evaluation of the art of one's own period and the reasons why extreme caution must be exercised in ascribing "bloom" or "decay" to it. It is always wiser to avoid using such morphological terms in regard to periods and styles.

Of course, a simple comparison of past and present attitudes does not tell the whole story. Ancient and modern paintings are the products of utterly different demands and conditions. In Leonardo's time, for example, all manner of details had to be considered in presenting the subject, and the completion of a painting might have required weeks,

months, or even years. Leonardo had worked on the portrait of Mona Lisa for four years when he was summoned to the Court of France. He took it with him and today we are not even certain that he himself put the finishing touches to it. Nowadays, however, paintings are generally executed very quickly. Their meaning, of course, is quite different. They depict something transitory, a feeling of inner tension and sensations. We are conscious of movement, of mood, when we look at them. Indeed, one often wonders why they are put into frames. Sometimes they look like the results of some research in an institute of experimental psychology. But should we, for this reason, call them "Un-Kunst"? (In discussions on modern art, conducted in English, Bernard Berenson liked to express his view by this German slogan.) They are, after all, products of our time and no opponent of modern art can deny that it has opened our eyes to the psychological and aesthetic aspects of colour and to the artistic beauty of line and form in themselves. Our appreciation of a picture is no longer governed by the subject matter. An abstraction by Michael Larionov painted around 1911, while showing the dissolution of naturalistic forms, still suggests a landscape. Its title is "Night of May" [Fig. 7]. Yet as early as 1912 Léger stressed the way he wanted us to consider one of his paintings as purely geometric forms by giving it the title "Contraste de Forme". In his painting "Yellow, Orange, Green", Kasimir Malevitch emphasizes pure geometrical forms and sharp chromatic contrasts [Fig. 6]. (The black-and-white reproduction does not render the exuberance of the colours). In sculpture it was Brancusi who showed us that highly stylized forms can be admired for a beauty of their own [Fig. 8].

In this connection one might also consider the often heard complaint that non-objective art is highly intellectual. No doubt the trend of 20th-century art has something to do with intellectualism, and by no means only when the geometrical constructions of Mondrian or Nicholson are under discussion. But one may well ask: can a work of art be produced without a certain amount of rational thought, without the use of the intellect? Intellectualism was also the charge levelled at modern music and it is easy to discover the intellectual basis of twelve tone music: the whole piece is constructed on the sequence and variation of tone series. Serial music, however, is written to be heard and for the listener the tonal effect is decisive; thus the question of whether the listener has understood how the piece was constructed is of lesser importance. It might also be asked whether musical composition has ever been possible without a similar use of the intellect. Was it ever possible to write a fugue without the ordering and control of that element of mind which we label "rationality"? Can the employment of motifs or the playing with themes and variations be the result of emotions alone?

As to the visual arts, was it not Raphael who composed a group consisting of a Madonna with the Child Jesus and St. John within a triangle? Are there any large compositions executed within these last six centuries that could not, eventually, be reduced to well-balanced diagrams and perspective constructions? In short, every work of art must be controlled in some measure by the "ratio". And it is this rational element that produces the discipline without which the work would be chaotic.

There are, of course, limits and it is possible that the intellect may become an authoritarian ruler. Similarly, too much

emotion can also destroy the balance of a work of art. It will always be difficult to define these limits or to apply specific standards because the judgment of the artist as well as of the beholder will always be subjective and, at the same time, conditioned by the psychological climate of the time. Let us consider just one of the many examples supplied by history. Around 1800, the German poet Heinrich von Kleist complained that artists and poets of his period were much more inclined to follow their intellect than their imagination. This is the language of a Romantic poet. On hearing it, a contemporary Classicist would have frowned and voiced his doubts. The contrasting concepts cannot be kept completely apart and may at times even become fused. The Swiss abstract painter Max Bill might be called a leading representative of the group that has discarded the word "abstraction" and that speaks of "concrete art" [Fig. 9]. These artists refer back to the manifesto written by Theo van Doesburg, the Dutchman who rejected any relationship with natural or realistic forms. Instead, he maintained, the artist should create mathematically precise, elementary plastic constructions or colour configurations. Born from the artist's inspiration and imagination, they possess a 'concrete' existence of their own.

At the beginning of this century there was a great desire for radical change, an unprecedented wish for something absolutely new. Compromise with the past was no longer considered possible. Completely new paths of self-expression had to be explored: Realism and Naturalism seemed sterile and obsolete. Gertrude Stein made it clear that even language had lost its vitality and that sweeping linguistic reforms were needed to give a new rhythmic life to prose and poetry. As early as 1906, in writing her first collection of short stories,

"Three Lives", she undertook a remarkable idiomatic re-
valuation in her attempt to revitalize the language. If one
wished to characterize the new element in her prose, for
example in the masterfully written story "Melanctha", one
could assert that there is a new *movement* in her language. And
movement became a watchword among the artists of this
period. Life is movement, movement life. This conviction
led painters and sculptors to experiment boldly and to
formulate the most extreme theories in their manifestos.
Matisse and his followers, the Fauves, who held their first
exhibition in the Salon d'Automne in Paris in 1905, led a
revolution which above all stressed novel forms and new
colours. There remained, however, some link with realism
in their art. Italian Futurism, as propounded in the manifesto
composed by Boccioni, Carrà, and others in 1910, wanted
to make movement itself visible. Everything static was taboo
for these artists. They were no longer interested in the formal
rendering of a streetcar; they wanted to portray it travelling
at full speed, they wanted to depict speed itself. Marcel Du-
champ's enthusiasm for movement found its classic expres-
sion in his famous painting of 1911—the second version in
1916—"Female Nude Descending a Staircase". Here, there
are just remnants of a stair and of a woman. The whole
picture can only be understood as a symbol for movement,
for quick descent. With such experiments the conventional
concept of space was abandoned and, since movement is un-
thinkable without a certain shift in time, one may speak of a
completely new conception of space and time. Boccioni him-
self gave one of his sculptures, a bronze figure shown in
movement, the title "Unique forms of continuity in space".
Even the Cubism of Picasso and Braque, though based on

premises quite different from those of the Futurists, has much to do with the same problems of space and time. Picasso's attempts to show the human head in profile and "en face" also follow the new conception of space and time in principle.

If we consider the important part played by the concept of movement during the past fifteen years, we are almost tempted to speak of a kind of "renaissance". Today, as fifty years ago, the obsession with movement is a dominant factor. The Futurists found in movement a way of getting closer to life itself and contemporary artists also find that life can best be expressed by movement, even by moving objects or machinery. The desire to express movement has led to serious and even brilliant new inventions such as Calder's mobiles and the glittering space sculptures of Richard Lippold. Though his space constructions are generally static, they seem to be in continuous movement since the stainless steel and wire constructions shimmer and glow in the ever-changing light.

Movement is not the only element in contemporary art that seems like a revival of the futuristic dreams of the past. Some modern abstract constructions, for example, are very similar to works produced by the Russian Constructivists around 1910. Their completely abstract reliefs, built in metal, wood, glass, and other materials, differ little from work done today in sculpture. The works of Malevich provide another striking example. The canvases he exhibited in 1915 in Moscow would not have looked out of place in New York in the early 1960's. One painting by Malevich that became a landmark in the history of modern art was nothing more than a square in black—reminiscent of one of Ad Reinhardt's black squares of 1961. As early as 1950, artists began to fill a canvas with only one colour. Suffice it to mention here Barnett Newman's

"Red Plains" (1950–51), or Clyfford Still's "Epic in Black" (1952). They, however, enlivened their one-colour plains with chromatic nuances. Even American action painting cannot be said to have progressed much beyond Kandinsky's early work, that is to say, beyond the huge compositions Kandinsky painted before 1920. Here one finds grandiose masses of colour painted with dramatic bravura. The powerful free play of grey and coloured "clouds" bears no resemblance to Kandinsky's later and better known style, where lines, geometric shapes, colours, and brushstrokes are held together in a kind of mathematical equation.

It is tempting to interpret abstract and non-objective art in the light of contemporary culture and philosophy. This would, however, exceed the limits of this essay and would, moreover, cover ground already well trodden. One thinks of the many analogies in literature like the tremendous revolution started by James Joyce, and one can follow parallel phenomena in poetry from Eliot's "The Waste Land" to the works of young poets in most countries today. As a further analogy one could mention the fact that, between 1910 and 1914, music disposed of Romanticism and traditionalism in as thorough a way as the figurative arts dispensed with representationalism. Suffice it to mention Schoenberg's "Pierrot Lunaire", a bold piece of music accompanying the text of an avant-garde poet, Albert Giraud (1912). Stravinsky's "Sacre du Printemps" (1913) represents a most powerful rejection of tonality in favour of new rhythms and hitherto unheard dissonances. This work coincided with Picasso's Cubist paintings and etchings. And while the artists and the literati discussed the "absolute" in art, Valéry spoke about "la poésie absolue".

Moreover, we can only hint at the importance of modern depth-psychology for the contemporary arts. It was psychology itself that helped to free man almost completely from convention. One could say that the Romantics' desire to give complete freedom to the artist became a reality at last. Mention has already been made of the philosophers of the Enlightenment and the Romantic poets who saw in the artist a kind of *Homo Dei*, capable of giving form to his innermost psychological reactions, relying solely on his feelings, emotions, and dreams. But the new psychology uncovered the alluring power of the unconscious and filled us all with the terrors of that underworld. No wonder that what W. H. Auden called "Our Age of Anxiety" left its mark upon the visual arts. The struggle against psychological fear has much to do with the lack of harmonious settings in contemporary art, and with the bewilderment and anguish that we find expressed in various ways in the work of many artists. This theme is clearly a symbol of modern man as he turns towards the dark mystery of the unconscious. It found its artistic expression in sombre works such as Paul Klee's painting: "Mask of Fear" [Fig. 13].

We should not forget, however, that in modern art we are confronted with a phenomenon which has left traces throughout the history of art. Through the centuries, realism and naturalism have been defied by counter-currents, by more introspective artists. Although they never went as far as to jettison external subject matter in favour of pure abstraction, they often did distort and deform their subject matter as they probed for its deeper meaning; or if they left the subject matter substantially intact, they frequently achieved their purpose by surrounding their subjects with an atmosphere of horror, of absurdity, almost of lunacy. The 16th and 17th

centuries, for instance, supply us with many such examples, and their profound relationship with modern works of art can be very striking. El Greco's art, with its strangely elongated and distorted forms and dramatic and mystical landscapes, is a case in point [Fig. 31]. One could also mention the spectral qualities, the predilection for the grotesque and the nightmarish in the works of Bosch [Fig. 10] and in the paintings of Arcimboldi [Fig. 12] several decades later. These characteristics may be found again in the work of modern masters like Dali [Fig. 11], whose work also points back to earlier ancestors, such as Breughel the Elder.

During the first half of the 17th century, Monsù, a not too widely known Italian Mannerist [Fig. 32], painted magical, phantasmagorical landscapes which, here and there, seem to live again in the sombre and uncanny landscapes of Max Ernst [Fig. 43]. One could also think of Bracelli's set of etchings of bizarre figures published in Florence in 1624 [Fig. 20]. It is often said that these "bizzarrerie" are the forerunners of Cubism. This is not so. These fantastic constructions are a product of the period's interest in technology and mechanical toys as well as of its penchant for the bizarre and the grotesque. What, then, do the monstrosities of Arcimboldi, the fantastic buildings of Monsù, and Bracelli's etchings have in common? They represent an attempt to break away from documentary realism and to give shape and form to reveries and dreams. It could also be said that logic and reason became less important than the irrational and the symbolic.

In addition to Ernst and Dali, there are other eminent nonabstract artists whose work is pervaded by a disquieting atmosphere. If we say that their work points back to Man-

nerism and Baroque, we are not so much interested in establishing cases of "influence"; rather, what is important is that their art is the product of a related psychological climate. The Belgian painters Delvaux and Magritte, together with the French artist Balthus, are outstanding examples of this. The paintings of Delvaux, in which every realistic detail is painstakingly recorded, achieve a poignancy through their creator's obsession with the impish and the grotesque [Fig. 16]. Magritte also uses naturalistic forms in composing his bizarre, surrealistic fantasies [Fig. 45]. Balthus, although a representational artist, is at the same time a visionary who infuses his paintings with a sinister and disquieting atmosphere [Fig. 15].

These examples should serve to remind us of how very cautious we must be in our criticism of contemporary art. We can easily deride or condemn certain elements which have, in one form or another, always existed in the visual arts.

Before concluding this brief discussion of modern art and some of its historical roots, we must make some mention of the process of dehumanization and denaturalization of the human form, perhaps the most characteristic feature of contemporary art. The idea that man is the measure of all things no longer exists, and therefore representational art, especially portraiture, had to disappear. It can hardly have been a coincidence that this happened in a world where individualism became unfashionable. There have always been introspective artists who were not satisfied with the merely realistic rendering of the human figure, but it has only been in modern times that the artist's imagination has transformed the illusion of reality into a vision or purely abstract patterns. It is not within the bounds of this essay to speculate whether and when

the human figure will again become the pivotal centre of the arts.

There is no simple answer to the question of why art, in an almost self-effacing manner, was driven to such extremes. We have, at least, considered some possible explanations. In the last resort, however, the development of history, of which art is an integral part, can only to a certain extent be explained rationally. Man is following strong and rather mysterious inner compulsions and unprecedented impulses. As Erich Neumann says: "We find various conscious motivations ... but a large part of this will for abstraction is unconscious ... It arises from a time trend in the collective unconscious ... beyond our differentiated modern consciousness." It was Neumann who, equipped with the knowledge of a modern psychologist, gave a compelling picture of the art of Henry Moore, which he characterized as the attempt to get back to archaic sources [Figs. 17, 18].

One could well write the whole history of our artistic heritage as the history of a conflict within the psyche of Western man, between an objective approach which leads the artist to the recognition of the outer, physical world, and a subjective approach, leading the artist to reject and dissolve naturalistic form. The unconscious current of which Neumann speaks oscillates continually between the subjective and objective polarities, and since the visual arts of the 20th century have been formed by their profound rapport with modern cultural life, it is within this continuous ebb and flow, this ever effective contrast between realism and anti-realism, that modern art has to take its stand. At present, of course, we have swung far towards the subjective polarity. The significance of anti-realistic art cannot be diminished, not

even by the innumerable hangers-on who have been trying hard to conceal their lack of talent beneath a cloak of abstraction.

The delicate question of whether this movement has reached a crisis or whether it is running downhill into anarchy, must remain unanswered. For good or ill, it has been a strong manifestation of the state of the human mind and, as such, has already become one more link in the perpetual chain of history.

II

Art and Technology

Reflections on Optical and Mechanical
Phenomena in Contemporary Art

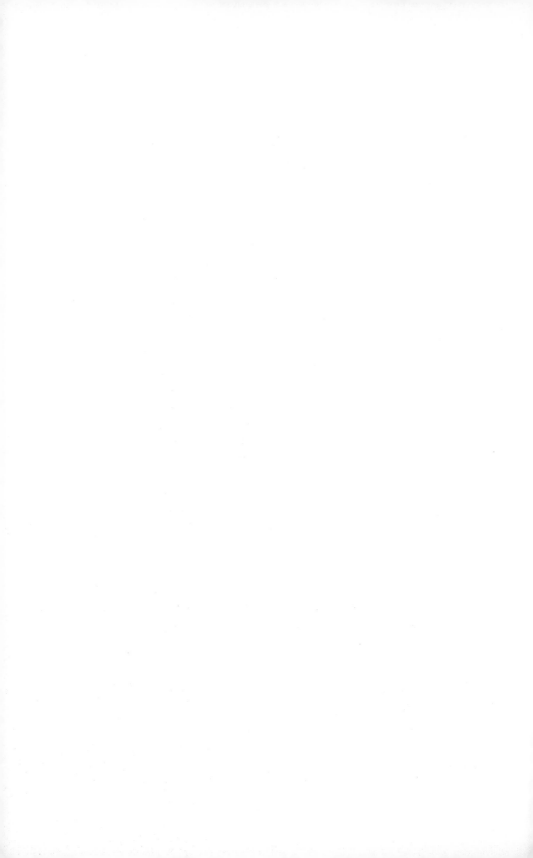

During these last few years exhibitions of "Op" art have been organized on both sides of the Atlantic. No satisfactory title, however, has ever been found for them. Such terms as "The Responsive Eye", "Retinal Art", or "Op" alone, did not seem to do justice to all the works on exhibition. An additional difficulty has been the fact that many people are still confused by the terms "Op" and "Pop", taking them to be directly interchangeable. In fact, "Op" and "Pop" art can only be understood by contrast. It nevertheless remains difficult to find a common denominator for the work of the various "Op" artists. The word "Op" suggests optical phenomena, yet in some cases such elements appear in conjunction with kinetic elements or mechanical devices. The most that can be said at the present time is that *light* and *movement* are essential characteristics of this contemporary trend in art which is itself developing in various directions.

The meaning and the interrelationship of the various directions may be more easily understood if we consider how and when the various terms, "Op", "Pop", etc., began to occur on both sides of the Atlantic. The new movement started at a time when abstract expressionism, which we might briefly characterize as a psychologically explicable form of self-expression, was at its height. The works of the abstract expressionists reflected individual feelings and emotions, in certain instances even archetypal experiences. This movement in the visual arts was counteracted, in sharp protest as it were, by what was proclaimed at the time as "Pop" art. It may appear that its greatest contribution to the arts has been

partially to halt the march of abstract art, for it is perhaps true that abstract art had become confined to an intellectual clique. Be that as it may, it is not yet possible to assess the full significance of "Pop" art, nor to give a clear definition of its major aims and scope.

Much more serious and convincing has been the movement known as "Op" art. This is again abstract or non-objective art, but it no longer presents images from what we usually think of as the unconscious. Emotion has been eliminated. In its place we find rationalism, mathematical reflection, and mechanical calculation. The inner relationship between the scientist and the artist in our technological age is therefore evident. Yet it would be erroneous and too facile to make too much of this relationship. It must rather be borne in mind that the new movement has its roots in the past, most notably in the art of the late 19th and early 20th centuries. It was at this time that simplicity of form and clarity of outline became important stylistic elements. It was Art Nouveau that first introduced linear simplification. An ornament by Van de Velde may serve to illustrate the artists' preoccupation with clear outlines and simple floating forms. Geometric abstractions also played an important part in Cubism, which was developed soon after 1900, and in the art of Kandinsky, whose book, "Concerning the Spiritual in Art", was published in 1912. By "spiritual" he meant abstract. After having experimented with pure colour combinations, he turned to geometric constructions. His theoretical principles were published in a new book under the title "Point and Line to Plane" in 1926. There was now an art form in which the human image had no place; it had been ousted by geometry.

Another radical rejection of naturalism occurred in 1916 when the Dadaists established themselves in Zürich. It was at this time that Arp began spraying hard-edged abstract forms onto a light ground—forms which continue to appear in today's optical art. To those of us who lived through those turbulent years, Dada did not seem to be a particularly constructive movement. And a few years later we were shocked when the young Surrealists, real grave-diggers of Humanism, proclaimed, amongst other heresies, that "All writing is garbage". We now know, however, that certain features of Dada were fruitful for later periods, and that some of its elements were even revived in "Op" art. A tapestry designed by Man Ray in 1911 consists of a large square filled with smaller ones in different colours, the whole representing a geometrical ornament. This is a motif that has never completely disappeared, and variations of it became a favourite theme of "Op" art, for example in the work of Max Bill. Marcel Duchamp, much to the surprise of those of us who remember him as the "Playboy of Modern Art", has also been very influential in two of today's art movements. Works such as "The Bicycle Wheel" of 1913, or the well-known "readymades", must surely earn for Duchamp the title of father—or grandfather—of "Pop" art. On the other hand, he also created highly complicated mathematical constructions which prepared the way for the "Op" artists.

Two other painters whose work has been a powerful influence up to the present day are Mondrian and Albers. Mondrian rejected naturalism early in his career, and in the seclusion of his Paris studio devoted himself to creating purely geometrical constructions, to what one might call "Rectilinear Geometry". It should briefly be mentioned at this point that

Mondrian's strict refusal to paint naturalistic works stemmed from religious convictions, as was also the case with Kandinsky. Under the influence of theosophy, Mondrian believed that by using vertical and horizontal lines he was getting nearer to the "Divine", and in these lines he found symbols for the eternal dualities, such as body and soul, masculine and feminine, good and evil. Many of his admirers, however, have long forgotten this irrational and mystical background to his art. It was the rational and mathematical character of his work that attracted so many followers, and because of this his aesthetics had a strong influence upon architecture as well as the applied arts. By 1920, Mondrian had developed the geometric style that has won a place in today's optical art. To cite one more example, Josef Albers's work is also geometrical, and his preoccupation with the square and its infinite variations is an important source for "Op" art. He became a teacher at the Bauhaus in the early 1920's, and his work there, together with the work of other Bauhaus masters, has exerted a strong influence on contemporary art.

It has already been mentioned that a controlled rendering of geometrical forms may be found in the works of Arp and Man Ray as early as 1915. Quite a number of artists followed similar directions during the following few years, the most important among them being van Doesburg, Lissitsky, and Léger. However, the rational approach and the use of geometrical pattern also found their way into the work of Klee, Delaunay, and Feininger. Even Picasso and Dali experimented with them. Stuart Davis's "Percolator" of 1927, and Charles Demuth's "Figure 5" of 1928 are perfect examples of clean-edge contouring and the juxtaposition of pure colour planes. One could also mention here Nicholson's paintings of large

squares and other geometrical forms in exciting interaction, and Magnelli's big colour planes, created, as it were, with ruler and compass.

Forerunners in the fields of light and movement are to be found mainly among sculptors. When Brancusi worked in metal, it was no longer just the form and line that impressed the beholder; Brancusi also achieved impressive light effects which foreshadow those in "Op" art. Naum Gabo's sculptures are another source of "Op" art. Although he was mainly concerned with problems involved in the interaction of positive and negative space (this is especially true of his earlier period), he obtained an aesthetic effect which was largely the result of the play of light. This is, of course, one of the main aims of the younger generation.

Gabo should also be mentioned in any discussion of the role movement plays in contemporary art. It was in 1910 that the Italian Futurists first tried to integrate movement into painting and sculpture, but the real founder of kinetic art was Gabo, who published his manifesto in 1920. The pre-occupation with movement spread, as did the interest in light effects. Some decisive steps in this direction were also taken at the Bauhaus. It was here that Moholy-Nagy worked on his "light machine", which he finished, after several years of preparations, in 1930. This "light modulator" served, as he said, "as an experimental apparatus for painting with light".

The relationship between music and colour requires at least a brief discussion, though it is far too complex a subject to receive more than superficial treatment here. There is a long history of attempts to construct a keyboard instrument which could be combined with optical effects. In the late

16th century, the Italian painter Arcimboldi constructed a colour clavicembalo, but we do not know how that "colour piano" worked. A few years before 1900, Wallace Rimington built a "colour organ", and in 1920, an American, Thomas Wilfred, produced his well-known "clavilux". In 1925 a "colour-light piano" was invented by the pianist Alexander Laszlo, who even wrote "Preludes for piano and colour-light". Incidentally, in the thirties, I myself attended avant-garde "light-shows", where the music of composers like Chopin was accompanied by moving abstract forms projected onto a screen. I cannot deny that the effect was rather stunning, since there was a convincing relationship between the changing multi-coloured dots and lines and the musical harmonies and melodies.

In this context, attention should be drawn to some remarkable recent attempts to make musical sounds visible to the eye. In 1965, during the Lucerne Music Festival the Swiss Hans Jenny showed the extraordinary results of some experiments he had made. The fascinating configuration was produced by a tone. Another such "tone-picture" is called "The Chladnic Sound Figure", after one of the fathers of modern acoustics, Chladni. These works provide rather convincing evidence that the optical reproduction of tones is profoundly related to the productions of "Op" art.

With all these observations in mind, the question arises: When did what we now call "Op" art really begin? Looking at a construction like "Linear No. 2", executed in plexiglas by Gabo around 1950 [Fig. 27], one would be inclined to classify it as "Op" art. Yet at the time the term did not exist. In the early 50's, Richard Lippold was working on a space sculpture entitled "Sun", a construction of shimmering

stainless steel and gold-filled wire that is one of the major achievements of "Op" art. In the late 1940's, artists at the London School of Arts and Crafts, drawing inspiration from the pioneer work with photograms of Man Ray and Moholy-Nagy, produced geometrical patterns which come close to the achievements of today's "Op" artists. They did more than simply deal with geometric patterns, however. There are "negative photograms" which demonstrate clearly that they were also attempting to generate certain light effects by using graduated shades. In one case the object used in the experiment was nothing more than a crumpled stocking.

It would be superfluous to discuss whether today's young painters are aware of all the earlier sources and forerunners. The situation is complicated by the fact that some of the innovators, Vasarely, Gabo, Albers, are still alive and working. The generations are overlapping. It is obvious, however, that the younger generations have developed new forms, colours, and media, and more consistently stressed the elements of light and movement. Broadly speaking, there are two ways in which they attempt to achieve these effects. They either work on plain boards, or they build ingenious constructions containing special mechanical devices for producing light effects and movement.

A leading exponent of the former method is Vasarely. Many years ago he began to arrange geometrical forms in a square, thus imposing on the eye an impression of playful movement. The work of the young artist Bridget Riley is also very arresting [Fig. 24]. Her patterns of broken or undulating lines on a white ground seem charged with a mysterious force, and constitute an artistic tour-de-force such as we have never seen before. These linear patterns are the result

of great precision, painstaking preparation, and impressive technical skill. The artist succeeds in generating movement, the ornamental design itself begins to waver. The spectator experiences a new way of stimulation of the retina, challenging the imagination, as well as perhaps a touch of vertigo. Her work suggests prior training in mathematics and technical design, but in a recently published article, Miss Riley strongly denies any relationship with scientific theory and scientific data. She asserts that her basic medium is just "perception". This is an important statement, and exactly the evidence we need to show that, in our scientific age, artists spontaneously or unconsciously arrive at scientific or semi-scientific solutions. There is a profound relationship between the aesthetic instinct and mathematical or technological phenomena, and though the interaction takes place on an unconscious level in the process of creation, the artist is often aware of this relationship, as witnessed by Miss Riley's comment: "I am well aware that the contemporary psyche can manifest striking parallels on the frontier between the arts and the sciences."

Other striking examples of the method of achieving light effects and movement are Ben Cunningham's "Equivocation" of 1964, in which the geometric forms generate a powerful movement, and Tadasky's "A 101", with its motif of concentric circles [Fig. 26] which seem to flicker and rotate. One should not forget, however, that similar experiments had already led Duchamp to his "Rotary Demisphere", (Precision Optics) of 1920 [Fig. 25]. The motif of concentric circles has always been a favourite with artists who have wanted to express themselves in abstract forms. Suffice it to mention the early Greek "geometric style", a Boeotian vase

of the 8th century B.C., or two spirals of a bronze fibula of the early Iron Age.

Let us now turn our attention to those artists who work with structures or constructions, and who attempt to achieve light effects and movement by the use of mechanical devices. Before we do so, however, we should point out that art and technology are very old associates. A French artist of the 13th century, Villard de Honnecourt, an architect as well as a sculptor, was very interested in moving "constructions". We know his sketch of a "perpetuum mobile", and among other works, he designed an angel and a bird, both of which could move. In Italy, around 1300, Giotto, now considered to be the founder of modern painting, was officially known as "Architect of the City of Florence". His world-famous tower is sufficient proof of his profound knowledge of mathematics and mechanics.

It was the 15th century, however, that became the real period of so-called "artist-engineers". Brunelleschi, a genuine technical genius, succeeded in doing what then seemed to be impossible, erecting the enormous Cupola of the Cathedral in Florence. Mathematics belonged to the normal curriculum of the artists, and some of them even composed technical works. Leon Battista Alberti, in his treatises, investigated linear and colour perspective as well as optics and mechanics. When he gives his definition of point, line, and plane, one is tempted to think of Kandinsky's publication of 1926. "De Prospectiva Pingendi" was the title of a treatise written by Piero della Francesca who, in his time, was highly praised both as a painter and as a mathematician. Perhaps the greatest artist-engineer, however, was Leonardo, whose genius encompassed all the sciences. Besides being a famous painter, he

was a fully-trained scientist and architect, excelling in hydraulics and ballistics. He wrote on geometry, mechanics and the theory of painting, and was perhaps the best trained and most knowledgeable anatomist before Vesalius. From the standpoint of the viewing public, the 15th century was clearly a period of change. People who had been used to the "subjective" space of the Trecento were now confronted with figures placed in a mathematically constructed Euclidean space. Though it is hardly possible for us to imagine their reaction to this use of scientific perspective in art, we are probably justified in believing that a great many were irritated, perhaps even bewildered.

The arts and sciences were also closely connected north of the Alps. Dürer, the painter, was trained as a goldsmith, and published books on proportion, practical geometry, optics, and architecture. Grünewald, the famous painter of the Isenheim altar in Colmar, accepted the job of an hydraulic engineer in the later years of his life while he was a political refugee. Fig. 19 shows a drawing from a book by the artist Wenzel Jamnitzer, which was published in Nuremberg in 1568. Evidence of the kinship between art and technology can be seen in the large number of polyhedric constructions.

The enthusiasm for geometrical forms and mechanical devices also reached a peak in Italy towards the end of the Cinquecento. In the etchings of Bracelli [Fig. 20], we find an extreme example of this interest in mechanization and automation. It is interesting to speculate on the inner relationship between Bracelli's "bizzarrerie" and the absurd and artificial language of his literary contemporaries, especially Marini, after whom the whole movement was named. Galileo re-

jected the absurdities of their language, and Salvator Rosa, a painter of great genius, ridiculed them with the lines:

"Maggior Poeta è
chi più ha
del matto."

"the greatest poet is he who is next to insane", which sounds intriguingly similar to many of the critical polemics one hears today.

The inventors of the 17th and 18th centuries should also be mentioned here, for although their amazing technical achievements did not lead to actual works of art, their association with figurative representation was of astonishing significance. In the Renaissance, gardens had been laid out with fountains surrounded by moveable statues, both statues and gardens frequently being constructed according to technical principles that had been established in late antiquity. Between 1700 and 1800 mechanized figures became the delight of the public, with Switzerland as a main centre of production. Figures were constructed that were able to play instruments, or read and recite aloud. One such figure, a trumpeter built around 1800, and now in the Museum of Science in Munich, was even able to play a number of musical pieces.

These mechanical figures, of course, were viewed as miracles of technology, whereas the modern mechanical constructions which we have been discussing serve aesthetic purposes. Yet there is some justification for mentioning them here. An investigation of the reasons for this early interest in technological inventions reveals a whole pattern of thought in the 17th century. Two names may suffice to clarify this statement: Descartes and Pascal. Descartes' "Discours de la Méthode", published in 1637, gave rise to a new rational

approach. Nature was to be explored and investigated by reason, by experiment. Only in this way, it was thought, could man become master of nature. Mathematical and mechanical research led to the construction of a wide variety of machines. Pascal paved the way for the future when, in 1645, he produced his calculating machine. A few years later, Leibniz followed with another one. Neither of these men was concerned with art or with artistic effects: in fact, their machines mark the beginning of a development that culminated in the modern electronic computer. Yet a certain relationship between their work and the technological character of contemporary art cannot be denied. As we have seen, the unconscious or spontaneous interest in technology has a definite place in the imagination of the artist. And it is precisely this aspect of modern art that is deeply rooted in the 17th century. Indeed one might conclude that the "Cartesian spirit" is a decisive factor in modern art.

Let us consider now some examples of "Op" art constructions that combine light effects and movement. These can be achieved not only by mechanical means, but also by specific formal relationships within the construction itself. The materials used vary from wood and canvas to iron, aluminium, rubber, nylon, plexiglas and the like. In a work such as "Balance 1956" by the Swiss sculptor Walter Linck, an extraordinary sensitivity and aesthetic sense is revealed. Another of his works, "Animated harp" [Fig. 29], is a convincing example of the astonishing effects such largescale iron sculptures can have when placed in the open air. The wind itself is responsible for the spinning and swinging movement of the structure, and the extent of this movement was, of course, exactly calculated.

Two other talented artists, both working in Paris, are Nicholas Schöffer and the Argentinian Julio Le Parc. There is no doubt that if some day Schöffer's cybernetic tower is built in the new "City of Paris", it will be hardly less of an achievement than the Eiffel tower was in its time. At night, when the 2000 or more lights and the 2250 projectors are in operation, the nearly 900 foot high sculpture will, as the artist himself says, have the effect of an "immense flame". Le Parc's "Continuous Mobiles" was executed in 1963. The aluminium construction excites and pleases the eye by light effects which cannot, unfortunately, be captured in a photograph. The same is true of the work of another Argentinian artist, Tomasello. His work can easily appear too rigid in photographs, but it achieves fine effects of shimmering light when seen in the open air. The inadequacy of photography to capture these light effects becomes apparent when we consider a work which can only be fully appreciated if seen by a spectator who is himself on the move. For this "Double Metamorphosis II", a recent work by Yaacov Agam, an Israeli artist currently living in Paris, is a fine example [Fig. 22]. It consists of aluminium coated corrugated wood, painted in vivid colours. As the spectator walks past this structure, it comes alive with movement and light. It is important to realize that this optic-kinetic structure is roughly the size of a large wall: nine metres high by six metres long. As Agam says: "Such works of art assume a really dramatic aspect ... when they are made on a monumental scale." Located on an inner staircase of the Israeli liner "Shalom", this imposing work stretches over three decks. The ideal spectator is the passenger going up or down the staircase, for he alone is able to see all the changes in light effects and movement, and to experience, as Agam

says, by virtue of these changes, the feeling of an enlarged and moving space. A quite different attempt to make use of large dimensions has been made by the Japanese artist Juko Nasaka. She has erected a wall almost three metres high by more than six metres long, and filled this spacious area with single squares, done in plastic paint, which merge, thereby forming one huge unit. Again, the intended optical effects can only be fully appreciated by a moving spectator.

That "Op" art can be combined with elements of space is obvious from the works of Agam and Nasaka, and the relationship between "Op" and contemporary architecture may be demonstrated by a comparison between the plexiglas construction entitled "Unstable Transformation" by the Spaniard Francisco Sobrino [Fig. 30], and the work of the modern French architect M. Y. Chaperot. From even a casual observation, the similarities between the architect's drawing and Sobrino's construction are obvious.

The work of Gregorio Vardanega, an Italian living in Paris, also represents a fusion of optical and mechanical elements. The big plexiglas globe [Fig. 28] which the artist built in 1960 is a striking example of this fusion. Vardanega appears to have been inspired by the massive glass globes which are used to represent the geocentric and heliocentric planetary systems in many science museums. Here, however, we have a fine example of the difference between science and art. The artist has been inspired by a technological construction, but he is mainly concerned with light effects and other purely artistic values.

Self-control and renunciation seem to be the main characteristics of the younger generation. It is as though these artists want, first of all, things cleared up and simplified. A look

at a painting like Philip Guston's "United" of 1958, or at one of de Kooning's many attempts to find a formula for the female nude while applying violent brush strokes to the canvas, suffices to make one feel that the younger generation of artists intentionally, if not unconsciously, revolted against the rising chaos of extreme abstract expressionism. A work such as "Accélération Optique", by Jean-Pierre Yvaral, or "Degree of Vividness", by Anuszkiewicz, clearly emphasizes the new generation's preoccupation with clarity, simplicity, and control. Although many people are still baffled by this new art form, it must be admitted that now one is at least able to breathe freely. A photograph of recent works by Vasarely assembled in an exhibition room [Fig. 21] shows, as it were, a "new order", a new purity and objectivity. George Rickey, himself an eminent abstract sculptor, and one of the connoisseurs of contemporary art, compared the new depersonalization to the piety of Fra Angelico. Even if we adopt a more prosaic language, we cannot deny that there is a certain chasteness in the younger generation. Artists now keep to what they can prove and calculate; they never give way to passion. Jackson Pollock used to say that while working he was *in* a painting. The young artists of today are always "outside"—they are their own most conscientious critics.

Renunciation can, however, be carried too far: a few stripes of colour are not a work of art. At best they are "trial-runs" for colour combinations. To quote Mr. Rickey once more: "Experiment is not art." The works of such artists should rather be called "samples". They have their rightful place in the applied arts, where they may find their way into patterns on drapes, wallpapers, posters, and so on. In this context it should be pointed out that the distinction between

art and applied art is becoming blurred. The Schools of Arts and Crafts of the last fifty years or so did some essential groundwork for the "Op" artists, who in turn are influencing commercial and industrial design.

One aspect of the modesty of the younger generation is the artists' tendency to conceal their individual personalities. By suppressing individual identity, by exhibiting their works under the name of a group, as for example the French group "Equipo 57", they give the impression of desiring to work on the new technical problems as a team, like a group of scientists in a laboratory [Fig. 23]. They also have a certain aversion to being called "Op" artists. Several years ago, many of them met at a Paris convention, where they referred to their work simply as "Tendance Nouvelle", or "Nouvelle Tendance, Recherche Continuelle".

Whether we choose to call it "Op" art or not, if we see in this movement a rejection of rank emotionalism and subjectivity, then we again enter the realm of history. Are we not faced with the conflict which has been experienced so often and expressed in so many ways—Classic and Romantic, Baroque and Classicism? Be that as it may, the young generation of "Op" artists seems to represent a strong rational movement, whose manifestations have their origin in the art of the early 20th century. The work of forerunners such as Man Ray and Duchamp was obscured by the great and lasting impact of Picasso's art and the subsequent non-objective art, but today we are witnessing a new wave; young artists, born into the satellite era, are now inspired by rational, optical, and mathematical problems.

Now is perhaps the time to consider briefly the place "Op" has attained in the history of thought. We have already men-

tioned that although non-objective art, particularly abstract expressionism, no longer recognized man as the measure, it could still be interpreted as a reflection of human feelings and emotions. Optical-mechanical art, however, makes its decisions "more geometrico". Here the dehumanization of art has become final. I was especially concerned with this phenomenon in a book published a few years ago in which I tried to explain it by retracing its development to the period of the Enlightenment and to the movement of French Symbolism. New research has led me to the conviction that the degradation of the human image also has strong ties with the literature of Romanticism.

One must first turn to Rousseau (1712–1778), who thought and taught that man is good, and that when he does evil it is due to outside pressures and stresses. A few decades later, everybody moulded Rousseau's philosophy to his own taste. It was in the works of the Marquis de Sade (1740–1814), that Rousseau's philosophy was most drastically modified. De Sade claimed that thieves, robbers, and murderers should not be punished, since nature distributed vices and virtues impartially. The highest virtue was the defence of the new Republic, which would fall back into monarchy and tyranny if man continued to believe in God and observe Christian ethics.

It is a strange but indisputable fact that although the "Divine Marquis"—as he was soon called—was neither a great writer nor an original thinker, he nevertheless exercised an overpowering influence on the subsequent literature of Romanticism, on writers, moreover, who were far superior to de Sade. His influence extended from Byron to Baudelaire and Swinburne, and even down to the decadents of the late 19th century. Novels such as "Justine ou les malheurs

de la vertu" and "Juliette ou la prospérité du vice" and other writings of de Sade which seem to us both dull and unbearably perverse, offered themes which contemporary and later writers eagerly took up. The enjoyment of evil, the idea of horror as a source of enchantment, the divine ecstasy of destruction, God as evil, nature as the work of the Devil, and all kinds of "delectatio morosa", such as corpses and their smell, and desperate deadly anguish—all these became characteristic elements of Romantic poetry. Even an "Association for the Encouragement of Murder" was formed. Byron's Manfred says proudly of Astarte: "I loved her and I destroyed her." As de Sade put it: "Oh! Quelle action voluptueuse que celle de la destruction ... cette divine infamie." And the glorification of Satan, another characteristic of de Sade, became a central motif in Byron's thought, and later found its way into the philosophies of Baudelaire and Swinburne.

These ideas were surely bound to lead to a devaluation, a degradation of the human image, the more so since the recognition and glorification of evil and ugliness as well as sadness found their way into aesthetics. In 1810, Germaine de Staël wrote: "La beauté même ne semble qu'une apparition effrayante," thus equating the beautiful and the frightful. Dumas wrote in 1829: "Viens donc, ange du mal." One can see in this something like a presentiment or even an anticipation of the aesthetics of Baudelaire. Under the influence of Baudelaire's strong personality, the recognition of evil, ugliness, and sadness loses its character of sheer satanic eroticism, and becomes a new poetic principle. In other words, the aesthetic of the beautiful is replaced by the aesthetic of the ugly. Baudelaire said: "Le beau est quelque chose de triste,"

and he describes his book "Les fleurs du mal" as "un livre destiné à représenter l'agitation de l'esprit dans le mal." This belief in "le génie du mal" foreshadows the ideas of poets and artists right up to the 20th century.

Characteristic of the changing aesthetic is a poem written by Rimbaud in 1870, entitled "Venus Anadyomène", in which he describes a hideously ugly nude female emerging from her bath tub. Huysmans' "A Rebours", written at the end of the 19th century, is indebted both to Baudelaire and to de Sade; the sadistic element also found its way into the work of Oscar Wilde: Salomé's erotic desires can only be satisfied by the beauty of a severed head, by kissing the bloody face of John the Baptist.

While I am well aware of having made a lengthy detour, it is clear that a glimpse at the literary history of the 19th century is necessary for our purpose. The fundamental change in aesthetic values briefly outlined above was, I think, a most important source for the degradation and final disappearance of the human image in modern art. The dissolution of the human form is most noticeable in Cubism, and in the destructive tendencies of Dada. Distortion of human forms and a preoccupation with sadness and ugliness are also characteristic features of Expressionism. In so-called "action-painting", something of human emotions lingered on, but when technology took over, portraiture and all other references to man as the centre of all things disappeared. Optical and kinetic art look to science, to mathematics and to mechanics, and have aesthetic values of their own. The dehumanization of the arts has been completed.

This thesis finds full support in contemporary literature. The developments in literature which we have briefly sur-

veyed did not stop in 1900. The degradation of man and the estrangement from human values are characteristic of the poetry, prose, and drama of today. Genet's "Journal of a Thief" is clearly related to the work of de Sade. Here theft and murder are no longer morally judged—they are facts with which we must live, beyond good or evil. There are criminals without crime. In Genet's plays we are confronted with schematic figures who have lost their identity, who merely play out their own illusions. Similarly, the "Theatre of the Absurd" is a game with cleverly directed puppets. In the plays of Samuel Beckett the characters are crushed and doomed wretches. Finally dehumanized, they live on as eyeless spectres, stripped of all dignity and only fit to vegetate in ashbins, or to suffocate and drown in mud. These remarks should not, however, be taken as a rejection, or even a criticism, of today's literature. I merely wish to point out that in literature, as in art, the human image has completely changed, and no longer has any real reason to exist.

At the conclusion of these reflections on art and technology, it would be tempting to add a few words about possible future developments in this field. This would, however, lead us into the realm of prophecies which it would be better to avoid. We cannot even say with certainty that technological art is the leading movement of our day. To be sure, as we have indicated, it encompasses Europe and America, as well as a part of Asia. However, art has always been the scene—if not the battlefield—of different, even contradictory movements. Picasso is still alive: abstract expressionism is not yet dead, and the art of portraiture, with its recognition of the visible and the tangible, still has powerful representatives: Wyeth, Hopper and Ben Shahn in America, the Canadian Calville,

Chagall and Balthus in France, Kokoschka in Switzerland— to mention but a few. History has never followed a straight path in the arts, nor for that matter in literature, politics, or philosophy. Delacroix's Romanticism did not oust the Classicism of Ingres; they rather developed and flourished side by side for several decades.

I hope this essay has given some idea of the relationship between art and technology during the course of history. We have followed the development of that relationship, and found it to be a long consistent process of rationalization with a growing tendency to combine geometric-ornamental motifs with optical-mechanical elements. We can, therefore, dismiss any premature criticism that suggests that the work of the younger generation is the result of complete subjectivity and arbitrariness. In striving for new methods, new optical effects, new technical skills, this generation is fulfilling a definite historical mission.

III

Art Theories and Manifestos
Old and New

(i)

Art and art theories have existed side by side since Greek and Roman antiquity. From Plato and Aristotle to Cicero and Seneca and the Hellenistic Christian philosophy of Plotinus, the historian repeatedly finds variations of the belief that the work of art is not so much the result of an imitation of the natural model as it is the realization of an inner image, an "idea", born in the soul of the artist. This conception acquired religious momentum in neo-Platonic philosophy (Plotinus). Since Christian doctrine holds that reality is imperfect, the role of the artist—with the help of his inner image—is to create something more beautiful and perfect than reality. Medieval aesthetics, as developed by such thinkers as Thomas Aquinas and Bonaventura, provided a theological basis for the metaphysical origin of artistic form with their concept of "similitudo": the work of art corresponds to the "simile" in the artist's soul, and this inner image is born by the grace of God.

At the end of the 14th century, Cennino Cennini wrote what is probably the first book about art for artists. He did not develop any specific theories, and his work remains essentially a craftsman's handbook. He does, however, besides giving advice on how to paint a panel or paint a wall in a fresco-like manner, suggest that artists should copy directly from nature. In the early 15th century, the artists themselves developed aesthetic theories, but since they had studied theoreticians such as Vitruvius and Euclid, they dealt largely with practical rules. Architects and painters like

Alberti and Piero della Francesca formulated practical aesthetics in handbooks on mathematics and surveying, perspective and colour, and they gave advice on how to apply these practical skills in the pursuit of "ideal" beauty. Alberti, for example, was already operating with a concept of "ideal" beauty which could only be achieved on the basis of experience and scientific study.

Soon afterwards, however, during the second half of the 15th century, Florentine humanists developed a new philosophy and with it a new aesthetic. In the so-called Platonic Academy, led by Marsilio Ficino, Plato's doctrine of "ideas" was merged with theories and doctrines from mystical and hermetic philosophy. Ficino's younger companion, Pico della Mirandola, was a staunch follower of the new system in which old Alexandrian culture, mixed with Greek, Roman, and Oriental elements, won new significance. It is a remarkable fact that at the time when the artists of the early Florentine Renaissance began to lean heavily on classical models and ideals, the new-Platonic thinkers began to develop a definitely anti-classical philosophy (though this itself had roots in antiquity, too). It may safely be said that the conceptions and theories behind the strongly anti-classical movements which arose during the course of the following centuries have had their origins in the philosophy of the Florentine Renaissance. This is particularly true of Mannerism, as this essay intends, in part, to show.

We should at this point mention Leonardo da Vinci, whose book on painting was of great importance not only for its time, but also for the future. Being one of the greatest scientists of his era as well as a great artist, Leonardo approached the subject of painting in a rather technical and practical

manner; his work is filled with advice about scientific methods of creating a work of art, but is relatively barren of aesthetic theories. We become aware of a new concept as we find Raphael at the beginning of the Cinquecento speaking of "una certa idea" as the starting point for each new work. While he used the term in a very general way, merely employing it to point out the origin of the form in his imagination, Platonic overtones are immediately recognizable here, as they are a few decades later in the writings of Vasari. For Vasari, however, the "idea" is the "concetto" which precedes and—in a much more specific sense than in Raphael's "idea"— predetermines the form. Vasari considered Raphael's work the nearest modern equivalent to the art of classical antiquity, and, accordingly, thought him the greatest artist of the first half of the Cinquecento. During his lifetime, however, Vasari modified his aesthetic theories. His history of art was first published in 1550, and a second edition appeared eighteen years later. In these years Vasari's admiration for Michelangelo increased tremendously; it approached almost idolatry, when he referred to Michelangelo as "divine". This revaluation brought with it a new theory of art which was destined to dominate aesthetics for most of the century.

Soon after Raphael's death, artists such as the two Florentine painters Rosso and Pontormo abandoned the ideal of classical beauty, and introduced a new movement which has been labelled Mannerism, a term used by historians to characterize the anti-classical current which spread from Italy to France and Spain and which lasted approximately a century[1]. The reasons for this rejection of classical ideals can only be briefly touched upon here. The 16th century began with a period of general unrest accompanied by great political and

religious crises. The Sack of Rome in 1527 shook all of Italy, and left its mark everywhere. The Reformation and the Counter-Reformation were also great sources of spiritual agitation and restlessness. There was a general feeling of anguish, a spirit of dejection, and a fear that the destruction of the world was imminent. J. S. Ackermann, in his brilliant essay "Science and Visual Art", says: "The early Mannerists ... expressed the disturbed and unstable psychology of their times." Or, as Professor and Mrs. Wittkower put it: "In the 16th century a veritable wave of melancholic behaviour swept across Europe."[1] But while these generalizations are true and provide a cogent and convenient explanation for the problematic development of the arts in this period, one still should be cautious. Changes in style and breaks with tradition have deep inner motivations which cannot be completely explained by rational means. It could be asked, for example, why it was that Dürer, deeply affected by the general mood of apprehension, did not develop a Mannerist style in his later period. Furthermore, it should be borne in mind that Mannerism went through several stages. The historical and psychological conditions under which the fantastic animal sculptures in Bomarzo (near Viterbo) were executed in the 16th century were certainly not the same as those in which the "double images" and allegorical flower paintings of Arcimboldi and the magical dream landscapes of Monsù were created. Moreover, it seems likely that the greatest influence was exerted by Michelangelo who, by casting aside classical ideals, tried to conquer the "materia" in a most individual, most subjective way. Considering the sheer power of his genius, it is easy to understand why the emotional and introspective artists of the 16th and 17th centuries turned from

the work of Raphael to the sculpture, painting, and poetry of Michelangelo.

Mannerism, as developed in the second half of the 16th century, also manifested itself in literature and in the semi-scientific publications which, in turn, exerted an influence on artist-readers. Della Porta (1540–1615), the author of "De Humana Fisionomia", published in 1586, was a typical and popular scientist of the period, and his book was a favourite with the Mannerists. Cesare Ripa's "Iconologia", first published in 1595, won so great a popularity that it had to be reprinted several times. These books, with their philosophy of half-truths and occultism, their magical explanations of natural phenomena, served as reference works for the artists. It is no surprise that the greatest scientist of the age, Galileo, was a bitter enemy of Della Porta, and that he ridiculed the metaphorical language and artificialities of the Mannerist poets. This background of magic and occultism explains such phenomena as the "museums of grotesqueries", a good example being the one in Prague, owned by the Emperor Rudolph II. It also explains why the Emperor was pleased to have as his Court Artist Arcimboldi, a painter whose absurd allegories could only be elucidated in the same way as the puns and metaphors of the Mannerist poets [Fig. 12].

It was not until the year 1584 that a Milanese painter, Giovanni Paolo Lomazzo, wrote the treatise on painting that is generally recognized as somewhat of a handbook on Mannerist art. According to Lomazzo, the artist should lengthen the limbs of his figures and decrease the size of their heads; he should make the whole figure describe a serpentine line. Following these guide-lines one was certain to produce beauty. Thus in this text-book for contemporary

artists, the standards of classical beauty had been swept aside. In Lomazzo's "Idea del Tempio della Pittura", printed in 1590, there is a bewildering and confused mixture of Aristotelian formulations, scholasticism and astrology which is characteristic of the half-scientific, half-fantastic literature flourishing around 1600. With a great deal of rhetoric and scholastic dialectic, beauty and art are proclaimed to be reflections of celestial beauty. Once again we have entered the realm of thought first evolved in the neo-Platonic Academy of Marsilio Ficino.

The neo-Platonic strain lingered on in the work of Federigo Zuccari (1542–1609), whose book, "Idea de' pittori scultori e architetti" was published in 1607 in Turin. This work became well known because in it he established the contrast between "disegno interno" and "disegno esterno". The former corresponds to what we have come to understand by the word "idea", and the latter refers to the created form. The "disegno interno", the inner image, must be made visible, and here Zuccari's theory comes close to the medieval concept of "Similitudo". He also stressed the belief that the inner image must be God-given, that it must be kindled by the "scintilla Dei". At the same time he thought that the process of giving the "idea" concrete form should not be aided by the exact sciences, "with the aid of rulers and compasses, but rather by observation of nature: ... we Professors of Design do not have need of any rules other than those which nature itself gives for imitation". Zuccari was also familiar with the concept of "fantastico" which allowed the artist to go beyond nature and to invent and use forms born of his imagination alone. These theories mark him as a typical representative of later Mannerism. It is in this period that

Monsù's fantastic paintings with their weird mixture of bizarre portraiture, architectural ruins and ghost towns, the whole pervaded by a fantastic religious symbolism, were executed [Fig. 32]. Recent research has stressed the Christian symbolism in his art, and, if this can be believed, it would seem that these pictures portray the collapse of the luxurious palaces and temples of the unbelievers.

Lomazzo and Zuccari lived in the period during which the strange literature of "emblemata" flourished. It began before 1550 and was in fashion for almost a hundred years. Emblem books were a combination of allegorical, mythological, biblical, and symbolic texts which were incomprehensible without the accompanying illustrations, and these woodcuts and engravings, in turn, were unintelligible to those who had not followed the text. It was also in this period that metaphorical language reached a peak in the poetry of Gongora in Spain, Marino in Italy, Donne in England, and—if comparison is possible—even Shakespeare; indeed, one general term for much of this complicated metaphorical style of writing is derived from the Spanish poet's name—Gongorism. It is not always easy for the modern reader to do justice to the bizarre and abstruse language of a poet like Marino, who enjoyed such a wide popularity in Italy and France at that time, nor to understand the mystical poetry of Donne. But in the final analysis, Mannerist literature does reveal the extraordinary sensibility and linguistic skill of the writers. Poets and artists alike evidently felt the tension and unrest, the absurdity and the religious instability of that period. In his poem "First Anniversary", Donne gave a most moving picture of his time. He described how the individual human being became bewildered and confused not only by the new

scientific discoveries, but also by the astrological, mythological, and religious explanations of their significance.

> 'Tis all in pieces, all coherence gone;
> All just Supply, and all Relation.

The pendulum of aesthetic norms began to swing back in the opposite direction towards the end of the 16th century when a new interest in classical ideals began to make itself felt. Arcimboldi, a typical representative of extreme Mannerism, was still alive when the counter-movement began. The heralds of the new movement were the three Carraccis, Annibale (1560–1609), Ludovico (1556–1619), and Agostino (1558–1602), who founded their own academy in Bologna in 1582. They were later joined by such artists as Guido Reni (1575–1642), and Domenichino (1581–1641). The reaction against Mannerism which began with the three members of the Carracci family was not pure Classicism, but it was the first great step towards it. A certain eclecticism is apparent in the work of the Carraccis—not altogether surprising since they admired Florentine drawing and the colours of the Venetian masters, as well as the art of Correggio and the compositions of Raphael. Raphael's influence increased after 1595, the year in which Annibale worked in the Palazzo Farnese in Rome [Fig. 33], developing a treatment of figures in landscape that anticipated Poussin[2], and generally evolving a decorative style that was to prevail for almost a century [Fig. 34]. The Bolognese painters advocated not only the study of nature and life, but also the study of the art of Antiquity and of the Renaissance, and they established a concept of beauty, sharply differing from Mannerist conceptions which demanded that natural forms should undergo a pro-

cess of ennoblement and idealization. A mere glance at the large canvas by Guido Reni entitled "Attalanta and Hippomenes" [Fig. 37], reveals that the school of Bologna was able to produce works that can stand comparison with Renaissance masterpieces as well as with the finest achievements of 17th-century Classicism.

The new movement found a powerful champion in the figure of Bellori (1615–1696), who set up an academy in Rome which was a favourite forum for discussions about art and aesthetics. His theories appeared in his book, "Vite de' pittori scultori e architetti", which was published in Rome in 1672. Bellori, supported by his friend Poussin, propagated the "Idea del Bello", an ideal beauty which could never be attained by "materia". Since nature alone was unable to achieve ideal beauty, the artist had to find a way to idealize the natural form. Bellori quoted Cicero, who had spoken of "that perfect and excellent exemplar in the mind". The ideal form could only be achieved by studying the best examples of antique sculpture and "for the ultimate excellence of these arts, by *selecting* the most elegant natural bodies". In Bellori's opinion, the artists who came nearest to achieving such beauty were the artists of Antiquity, and, after them, Raphael. His admiration for Raphael was so great that he relegated everything produced by later artists to a second-rate status. Michelangelo was no longer "divine"; divinity had been bestowed on Raphael.

It is clear from even these few remarks that Bellori, who could find no praise for the Mannerists, encountered difficulties when faced with the works of a great Venetian master like Titian or a Lombard painter like Correggio, and, above all, when trying to do justice to the great art of Caravaggio.

Although he could not deny Caravaggio's remarkable talents, Bellori was of the opinion that he merely imitated the model and that his paintings lacked precisely those qualities— "bellezza", "selectio", and "idea"—which were essential to all great works of art. Nowadays it is almost impossible to understand how Classicists like Bellori completely missed the glowing visionary and dramatic qualities in Caravaggio's work. It is almost equally impossible to understand how, on looking at the painting of St. Paul in S. Maria del Popolo [Fig. 39], they failed to grasp not only the supernatural power of the work, which raises it above the level of mere portraiture, but also the magical effects produced by Caravaggio's handling of light and shade—the arresting chiaroscuro that was soon to conquer European painting. They did, however; in Bellori's opinion, "Caravaggio painted men just as they are".

Bellori's theories were partly the result of his long friendship with Nicolas Poussin, who had arrived in Rome in 1624 and remained there, with only a single interruption of two years, until his death in 1665. Poussin, the Frenchman, became the leading Classicist of the Italian Seicento. He passionately admired the sculpture of antiquity, as well as the art of Raphael, who, in his estimation, was the greatest artist of all [Fig. 35, 36]. Poussin tried to raise art to a higher, a poetic reality. Nature had to be surpassed, ennobled, idealized, and this could not be done without employing the intellect. In his paintings of historical and biblical scenes, indeed in all those works where human figures appear, Poussin constructed a kind of stage on which each figure had a definite place. This was an era of great activity in the theatre, and saw the rise of the pastoral play and the beginnings of

opera in the modern sense. Looking at the crowd scenes in some of his paintings, one has the impression that Poussin worked like a stage director, establishing not only the correct place for each figure, but also arranging every pose and gesture with precision. There is no reason to doubt the traditional belief that Poussin, before commencing such a work, made small figures in wax and placed them on a flat ground—"blocking out" as they say in the theatre referring to the working out of the positions and movements of the actors during rehearsals. Be that as it may, Poussin became the great master of composition, and as such he not only guided his contemporaries, but also served as an example to modern masters, above all, to Cézanne.

The danger in stressing the rational side of the creative act lies in the fact that art can thus become academic. In some of his paintings, especially where there are many figures, one may perceive Poussin the theorist. But there is another Poussin, the artist who painted a new Arcadia, landscapes with mythological or pastoral figures in glowing colours reminiscent of Titian [Fig. 38]. In these works it is as if he forgot, or at least put aside, his rigid theories. One is reminded of a parallel phenomenon in contemporary music. Claudio Monteverdi was highly preoccupied with the philosophical, theoretical, and aesthetic aspects of his art. Modern musicologists, however, observe that "Monteverdi was at his best —an irresistible best—when he forgot about theories and just wrote music",[3] "when he had no time for invocation of Plato or classical scansion ... but was forced to apply his dramatic insight and aesthetic judgment".[4] The interaction of theory and free inspiration is one of the ultimate secrets of the artist, and even Poussin himself declared that art could

not be learned. "C'est le rameau d'or de Virgile que nul ne peut trouver ni cueillir s'il n'est conduit par la fatalité."[5] It was this higher poetic gleam that filled Lorenzo Bernini with awe and admiration. Although viewing art differently from Poussin, he was deeply moved, even overwhelmed, by some of Poussin's paintings when they were shown to him by Sieur de Chantelou. This explains Bernini's exclamation: "Indeed a veritable poet!"

Poussin was at the height of his fame when the French Academy was founded in Paris in 1648. Seventeen years later Colbert opened the French Academy in Rome. The Academy soon became the most important centre of the arts in Europe, yet Poussin's art and ideas remained unchallenged. Sieur de Chambray, for example, dedicated his book, "Idée de la parfaite peinture", to Poussin, thereby clearly indicating that he had developed his theories in collaboration with this artist. And since Le Brun, President of the Academy for twenty years, was also an admirer of Poussin, there was little change in the main aesthetic principles during this period. In their lectures, the Members of the Academy took every opportunity to stress the need for clarity, grace, and decorum in art, qualities that had already played a dominant role in Poussin's art. On the other hand, however, Poussin also came in for some criticism. But it was criticism of a kind which strikes the modern observer as rather petty. Philippe de Champaigne, for example, in a lecture on Poussin's "Rebecca and Eleazar", criticized the artist for falsifying history by omitting the camels which the Scriptures mention in connection with Rebecca. Similar accusations were made in other heated discussions at the Academy, and often the conflicting views could only be reconciled by a word from Colbert himself.

But as always in history, movements generate counter-movements, and neither Italy nor France in the 17th century were spared them. There were theorists who preferred colour, and turned to Titian and Correggio for their examples. Thus, even among the artists of the Academy, unanimity could not reign for long. Some of them believed that the importance of colour was underrated, and the study of antiquity over-rated. Artists such as Mignard and Philippe de Champaigne, Richelieu's favourite painter, admired the Venetian colourists of the High Renaissance, and some even became enthusiastic about Rubens. There were also some major artists who, partly because of the influence of Caravaggio, partly under Flemish influence, estranged themselves from the ideals of the Academy. Suffice it to mention the three Le Nain brothers, Antoine (b. 1588), Louis (b. 1593) [Fig. 40], and Mathieu (b. 1608), and Georges de la Tour (1592–1652). It is not surprising to find an Academician like Félibien reprimanding these artists in much the same terms as Classicists like Bellori had used to criticize Caravaggio.[6] Since he could not deny their skill as painters, Félibien had to confine himself to criticizing them on the grounds that they cared little for "beauty" and "ennoblement".

This period also saw the beginning of the quarrel between the "Ancients" and the "Moderns". As early as 1620, the Italian Tassoni had praised contemporary art and ridiculed what in his opinion was the exaggerated respect in which the art of antiquity was held. In France, men of a similar persuasion became hostile to the dictatorship of the Academy with its glorification of Ancient Roman art and mythology. Charles Perrault, in his book, "Parallèle des Anciens et des Modernes", dared to disapprove not only of Poussin's admira-

tion for antiquity, but also of the theories of the Roman Academy. He praised contemporary art, in particular the grandeur of the period of Louis XIV. When dealing with this quarrel, Julius von Schlosser was prompted to quote Angélique's spirited outburst in Molière's "Le Malade Imaginaire", written in 1673: "Les anciens, monsieur, sont les anciens, et nous sommes les gens de maintenant."[7]

Classicism, however, never completely disappeared. It has manifested itself in Western art in various forms again and again, particularly as a counterbalance to naturalistic movements. In the 18th century, philosophers, poets, and artists tried to jettison all rules and conventions in favour of naturalism. Denis Diderot (1713–1784), a good example of an 18th-century naturalist, was more of an art critic than an aesthetician, which is evident in the reviews he wrote of the exhibitions in the "Salon". In his writings, free discussion replaced the rigid doctrines that the French Academy had imposed for so many decades. And yet, after a comparatively short interval, Classicism again was revived in France with David (1748–1825) and Ingres (1780–1867) as its leading representatives. In Germany Winckelmann (1717–1768) strongly emphasized the beauty of classical art as well as the genius of Raphael. The art of Raphael and the art of Greece were also given as perfect examples by Sir Joshua Reynolds (1723–1792), who urged his students to strive for a higher form of beauty, an "intellectual beauty", as he called it. In his "Discourses" at the Royal Academy he recommended that nature and the works of the ancient masters be studied together. His conviction that this was the way to achieve a higher form of beauty is reminiscent of the beliefs current in Italy and France in the 17th century.

Around 1800 Romanticism began to spread throughout Europe. The poets, critics and philosophers of this movement continued the work begun by their forerunners, whose attempts to free man from convention had shaken England, France, and Germany during the second half of the 18th century. They had fired the first shots in the war against academic rules and conformity, and had fought for the spiritual and creative independence of the artist. These ideas and principles lived on in Romantic philosophy and aesthetics, and here the struggle for the freedom of the individual culminated in a rejection of all boundaries and limitations, in a desire for infinity. Hegel, in his admirable lectures on aesthetics, once spoke of the "inexhaustible rambling of the imagination". According to aesthetic theorists like Novalis, paintings had to have exciting colours regardless of subject matter, and poems had to become music. The artist was not to seek some form of abstract beauty; rather he should seek the most suitable expression for his own aims and ideas.[8] Romantic philosophers and poets discussed the possibility of writing poems without meaning or logical connection, and in the poetry of the period one finds remarkable uses of contradiction and irony, artificiality and abstruseness. From these few remarks it is evident that many of the aims and ideals of Romanticism are of the utmost importance for late 19th-century poetry and, finally, for the figurative arts of the 20th.

(ii)

The 20th century's battle for new cultural and artistic values began with a shrill fanfare when Marinetti's violent attack on contemporary culture appeared in "Figaro" in February 1909. One year later, the Italian Futurists, Boccioni, Carrà,

Severini, Russolo, and Balla, published their revolutionary aesthetics.[9] Their main preoccupation was with movement, and among their favourite subjects were human figures in motion and vehicles travelling at high speed. Their work is significant not only because it marks a new approach to art, but also because their works, and the philosophy behind them, contained many elements which became important for the art of the following decades.[10]

Another Italian artist, who developed in a totally different direction during this period, was Giorgio de Chirico. He is the main exponent of what is called "Metaphysical Art". His paintings are full of imaginary "ghost towns", haunting in their emptiness. The squares and streets of his towns seem more uncanny when a child is realistically portrayed in them, and even more so when metallic phantoms altogether replace life-like figures [Fig. 14]. These weird creatures and the architecture, which has a look of utter desolation, evoke an unreal, dreamlike atmosphere.

At roughly the same time, Picasso and Braque were developing another revolutionary art form, in which, although there was no direct connection with the Italian Futurists, the concept of motion also played a leading role. In Cubism the object or figure is shown in motion: Moholy-Nagy called it a "multi-view system, a simultaneous vista". Yet the Italian artist Boccioni, in his book published in 1913, characterized Cubism as "static", in contrast to "dynamic Futurism".

The artists in Paris, however, did not write their own manifestos, and the role of prophet fell to the poet Apollinaire. Nevertheless, one should not overrate the influence of poets and theorists on creative artists; if anything, the influence flows the other way. When, in 1912, Apollinaire

defended the non-figurative work of his artist friends, it was he, the theorist, who had been affected and impressed. In that year, he was excited by the work of his new friends Robert and Sonja Delaunay, who had just begun to create and experiment with pure colour compositions, "simultaneous contrasts" as Apollinaire called them. He was fascinated by the breaking-up of naturalistic forms, and by the rejection of coherence and continuity. In his estimation, these were achievements which could also be attained in poetry, and he set about proving this by dispensing with logic in his own writing.[11] This parallelism of the arts in Cubism should not, however, be allowed to obscure the fact that the artists were acting, so to speak, without precedent, whereas the poets could look back to Romanticism and even to the emblematic and ingeniously metaphorical language of the 17th century. In 1912, both Marinetti and Apollinaire were writing in what could be called a neo-Romantic or neo-Baroque style, and it is reasonably certain that both were familiar with the literature of these two periods. More than thirty years before, Rimbaud had occupied himself with the "alchemy of the verb" and the "colour of vowels" in his attempt to express the inexpressible.

While Cubism was being developed in France, and Futurism in Italy, Kandinsky, Marc, and Klee were working out their own theories in Germany. Marc and Kandinsky were convinced that the imitation of the natural form was both unnecessary and mistaken, since there was something beyond the mere outward appearance of things. They called this "inner reality" the "absolute", and maintained that it could only be expressed by abstract forms. Seen historically, this conviction is no more than a symptom of the old fear that

art could degenerate into nothing more than cheap imitation. It is, in other words, another variation of the Platonic scepticism which has been observed repeatedly in the course of this investigation. Kandinsky's struggle for the "spiritual" and the "absolute" in art is reminiscent of Romantic aesthetics, and he is certainly in line with them when he states that the "spiritual" and the "absolute" can only be attained by sounds, by music. When explaining the composition of his paintings, he often used words like "rhythmic", "melodic", and "symphonic".

The breaking up of naturalistic form meant the end of representationalism and of all other forms of culture that had been based on humanism, causality, and logical thinking. The need for radical change constituted the main theme of the majority of manifestos in which the artists themselves proclaimed their aesthetic, or more exactly, their "anti-aesthetic" principles. It is sometimes difficult to take their pronouncements seriously, and it is sometimes even difficult to imagine what they mean, for example, when the Dadaists talk of depicting "real life". It should not be forgotten, however, that this group of young artists and poets in Zurich consisted of war refugees who, revolted by the cruelty and stupidity of war, were intent on destroying everything which, in their eyes, had contributed to the evil surrounding them. In this situation, they found refuge in bitter humour, and even in the proclamation of nonsense. Hugo Ball, a self-styled writer of "verses without words", called Dada a "harlequinade made of nothing". The French poet Tzara wrote seven manifestos and many nonsensical poems which were illustrated by Hans Arp. Of the Zurich group, it was Arp who developed into an artist of outstanding stature. He himself,

much later, said: "I write fairy tales and the content of my sculptures is also fairy tales and dreams" (1960). Indeed, when reading his poems, or his introduction to Max Ernst's "Natural History", written in 1926, one is hardly able to find one's way through the maze of words and sentences which seem to have no rational meaning. His sculptures, however, are a different matter. Although they are purely abstract, they do give the spectator a great deal of aesthetic pleasure.

One other aspect of this movement deserves mention here —the "live performances" of Dada. With grim humour and mischievousness, poets and artists in Zurich deliberately set out to shock their audiences in the Cabaret Voltaire. The reading of poems consisting of one word repeated one hundred and fifty times was only one of the many devices used to outrage the public. Eye-witness accounts of the performances sound like descriptions of present-day "happenings". Indeed, in many respects, we are now going through a kind of neo-Dadaism with all its typically chaotic manifestations.

The Zurich manifestos were in their own way typical products of this great period of rebellion in the arts. There were Dadaists before Dada, and Dadaists long after the Zurich group had ceased to exist. The post-Zurich manifestos of Dada, especially the German one produced by Hausmann, may safely be forgotten. Their mixture of politics, social problems and nonsense makes them, if anything, more confusing and confused than the earlier manifestos. There was only one very serious manifesto, and it came from Russia. It was produced by Gabo and his brother Pevsner, who in 1920 introduced "movement" again as the most important impulse for artists. This was a catchword that had been interpreted rather differently by the Futurists.

Dada was firmly entrenched when André Breton produced his first manifesto of Surrealism. The term itself, of course, was not new: Apollinaire had coined it years before. Nor, indeed, did Surrealism suddenly begin when Breton's manifesto appeared in 1924. Surrealist elements can be found as early as 1912 in the work of Duchamp, and from 1915 onward they appear in the mechanical style of Picabia in New York, and in the work of Man Ray and Max Ernst. The latter's "Surrealist" paintings, sculptures, and collages were executed three or four years before Breton appeared on the scene. Ernst's painting "The Elephant of Celebes", in 1921, may be considered a typical work of Surrealism. Breton, who gathered the young poets and artists under his flag, wanted a clean break with Dada, but elements of this older movement lingered on in Surrealism. It is, for example, difficult to find any significant difference between the bicycle wheel exhibited by Duchamp in 1913, and the bed which was put on show in London in the mid 30's.

Breton's greatest ambition was to create a new, well-organized aesthetic system, something the Dadaists had failed to do. To this end he proclaimed his doctrines with great vigour in numerous manifestos. The main elements of his aesthetic theory were "pure psychic automatism", the exclusive reliance on the imagination and dreams, a belief in chance, a dialectic materialism, a desire to eliminate all forms of control, and finally, as a corollary of the last, a fanatical anti-intellectualism. All these ideas were propounded with a great deal of pomp, demagoguery, and arrogance. Breton was a gifted author and poet, and yet one may wonder whether so much intellectual energy had ever been wasted before in trying to prove that the intellect is both useless and

dangerous for the creative artist. He was, however, eminently suited to be the promoter of the new movement. He was acquainted with the language of the Mannerists and with Romantic aesthetics, as well as with the work of Rimbaud, Lautréamont, and Jarry, and even with medieval occultists such as Raimundus Lullus. Yet in his pride as a pioneer, he went to the ridiculous extreme of denying any influence from the writers and artists of previous centuries.

Breton's first manifesto was announced by Louis Aragon with the words: "A new vice has just been born, one madness more has been given to man, Surrealism, son of frenzy and darkness. Step right up!" This startling statement is an unlikely introduction to a serious aesthetic theory. It is impossible to take Breton seriously when, in his second manifesto, he blandly remarks that: "The simplest Surrealist act consists of going out into the street, revolver in hand, and firing at random into the crowd as often as possible." To what extent such statements were nothing more than swaggering bluff and sprang from a perverse pleasure in shocking the public, is hard to determine. Relevant to an understanding of the spirit in which to take such comments, may be René Clair's recent account of the uproar caused in the "Théâtre des Champs Elysées" in 1924 by Picabia's ballet and the film of his own work, "Entreacte". He remembers that he and Picabia just wanted to shock. They did not want applause, they wanted violent protest, and when protest broke out the two young artists laughed heartily at the bewilderment of the outraged audience. As René Clair says, they were out to "provoke" and to "mystify".

It was Max Ernst who became the most outstanding representative of the type of Surrealism Breton had in mind.

Ernst was, however, a fully-fledged Surrealist some years before Breton wrote his first manifesto, and was therefore less Breton's disciple than his congenial companion. His work was very much the expression of his personal genius, and his autobiographical writings furnish clear proof that he had always been attracted to occultism, clairvoyance, magic, and witchcraft. Small wonder, then, that he listed Novalis, Rimbaud, Blake, and Lautréamont among his favourite poets. But did he not deceive himself when he concluded that "collages" and "frottages" were highly characteristic examples of "automatic" Surrealism? They are rather techniques, methods which he explored and which opened new artistic horizons. They may have been of little assistance to other artists, but they enabled him to express his own poetic, confusing, and often disquieting visions. When he once spoke of "systematic confusion" in relation to his collages, he unknowingly used the same words as the Romantic writer and philosopher Friedrich Schlegel, who had written about "eine künstlich gestaltete Verwirrung"— "an artificially created confusion". Indeed, odd fragments of real objects, taken out of context and fused together, do often provide new insights, as Ernst himself remarked: "They opened a new field of vision by upsetting the relations of realities". Only in the very best examples of Surrealist art, however, can "systematic confusion" be enjoyed for its particular poetic or mystical qualities [Fig. 43, 44].

The above statement does not entirely apply to Salvador Dali, whose genius won wide acclaim, but whose "showmanship" found many opponents. Dali's work has strong affinities with 17th-century Mannerism, and he is not afraid of making bold use of such models [Fig. 11]. Too much aware,

perhaps, of his genius and skill, he does not even remain consistently a Surrealist, and sometimes loses himself in his own capriciousness. If Max Ernst moves away from Surrealism, Dali actually plays with it. Having such a protean temperament, he could not follow André Breton for long.

Dreams played an important part in Surrealist aesthetics. They were, however, also an integral part of Romantic philosophy, as well as of Elizabethan poetry. During the first half of the Seicento, the Italian artist Francesco Montelatici, also known as "Cecco Bravo", was considered to have a genius for portraying fantastic subjects. His admirers called his paintings "dreams", while others, more critical, called them his "horrible dreams".[12] This interest in dreams led the Mannerist artists and poets to investigate the mysterious border between the conscious and the unconscious. The distinction between dreaming and wakefulness became somewhat blurred, and sometimes even eliminated. In the words of Shakespeare:

> "We are such stuff as dreams are made of,
> And our little life is rounded with a sleep."

(iii)

This essay has, in part, been an attempt to trace elements of 17th-century and Romantic thought in contemporary art, particularly in Surrealism. It has been suggested that only now have the artists and poets taken full advantage of that total freedom of the imagination propagated by philosophers and poets around 1800. However, the impact of Romanticism on the visual arts of the late 18th and the 19th centuries should not be underestimated.[13] The artists of the 19th cen-

tury did not, of course, create abstract works of art, but they did harbour a desire for complete creative freedom. We must limit ourselves to a few examples here, ignoring in this essay the role that Delacroix played in the history of Romanticism. One important example is the art of William Blake (1757–1827). The dreamlike, fantastic qualities of his poems found clear expression in his paintings and drawings, which are filled with creatures who only partly belong to our visible world. They seem to be demons or phantoms born of the artist's powerful imagination [Fig. 41]. A dreamlike quality also pervades the more sensitive works of Blake's friend, Henry Fuseli. There is a demoniacal quality in some of his works that leaves the beholder in no doubt that the artist was haunted by obscure, indeed sinister fantasies and wild anxieties. His contemporaries found his work bizarre, shocking, mad, and nightmarish—adjectives which could equally be used in any discussion of Surrealism [Fig. 42].

Any attempt to follow in detail the effect of Romantic philosophy on the figurative arts of the 19th century would far exceed the limits of this essay. There were many artists in France, England, and America, who served as links in a chain stretching from Romanticism to Surrealism. There were architects who designed buildings so fantastic that they could never have been constructed from any material (Ledoux, Boullée), and there were artists who kept to natural forms but surrounded these forms with a mysterious and unreal atmosphere. Two of the most outstanding representatives of this type of art were Gustave Moreau and Odilon Redon. Redon anticipated the work of the Surrealists, particularly in his early graphic work, where he created a world of nightmares, dreams, and ghoulish phantoms.[14]

And it was also during the latter part of the 19th century that French poets produced works which come extremely close to Surrealism. Towards the end of the 1860's, Lautréamont wrote his "Chants de Maldoror". His fight against God and mankind is reminiscent of the period of the Enlightenment, and his horrific scenes and nauseating stories, many of them pervaded by a brutal eroticism, are clearly influenced by the work of de Sade. He shared with Edgar Allan Poe the power to make the reader shiver, and this alone must have recommended him to the Surrealist generation. On the other hand, some of his own comparisons and metaphors are strange enough to deserve the epithet "Surrealistic" themselves. He formulated his aesthetics in one sentence: "Beauty is the accidental encounter of a sewing machine and an umbrella on an operating table". One is tempted to assert that this sentence marks the birth of Surrealism.

We would be straying too far if we followed the aesthetics of French poetry from Rimbaud to Apollinaire, Eluard, Valéry, and others. All were deeply indebted to the 17th-century Mannerist poets. Their work may be characterized as a new kind of Gongorism, in which linguistic acrobatics, abstruse playing with letters (letterism), and monstrous neologisms were dominant. But we may at least mention one of the most important forerunners of Surrealism—Alfred Jarry. The bizarre Guignol of Père Ubu, the stage setting designed by Jarry for the play, and his own speech to the stunned audience at the First Night in 1896, added up to a grotesque and nonsensical programme that the Surrealists could hardly have surpassed.

In recent years scholars have become more and more aware of the relationship between Mannerism and Surrealism.

In the 1920's, however, no one had a deeper insight into this phenomenon than T. S. Eliot. It was in 1921 that his essay "The Metaphysical Poets" was published.[15] One year later "The Waste Land", one of the most remarkable poems of the 20th century, appeared. Erich Heller has pointed to the connection between the essay and the poem, arguing persuasively that the poem owes very much to the philosophy and poetry of the 17th century.[16] As Eliot pointed out: "In the 17th-century a disassociation of sensibility set in, from which we have never recovered." Discussing Donne and the metaphorical language of Shakespeare, he speaks of "an eccentricity of imagery, the far-fetched association of the dissimilar or the over-elaboration of one metaphor or simile ... a development of rapid association of thought which requires considerable agility on the part of the reader". Eliot's characterization of 17th-century poetry would serve as an ideal introduction to modern poetry, indeed to modern art. Contemporary artists, he thinks, must be "complicated", since "they are facing the complex and complicated situation of the overall pattern of modern psychological and cultural perplexity". With a conviction born of experience, he asserts that poets nowadays must be "difficult", and continues: "The refined sensibility of this civilization must produce various and complex results. Artists and poets must devour every kind of experience. The poet must become ... more indirect in order to force, to dislocate if necessary, language into his meaning." It is no longer sufficient to rely on feelings, the artist and the poet "must look into the cerebral cortex, the nervous system, and the digestive tracts".

(iv)

It is perhaps now time to ask once again to what extent artists are influenced by art theories. No art theory has ever been the cause of a new art movement, although the theory may influence and stimulate it. Even if the artist is himself the theorist, as was the case with Poussin, or, in modern times, Kandinsky or Klee, the creative act remains something irrational. As Bernard Berenson puts it in his book "Aesthetics and History" (1954): "I doubt whether one can know the mind of the artist even through the confession of the artist himself". Indeed, no artist has done more than Kandinsky to stress the essential isolation of the artist when creating a work of art. Again and again he mentions the "principle of inner necessity", which he calls a mystery. It is also doubtful whether Klee's theoretical handbook, "Pädagogisches Skizzenbuch", published in 1926, can be called a reliable guide to the artist's dream world. Yet a certain relationship between theory and the finished work does exist. Philosophers, poets, and artists of any period do share a common spiritual, intellectual, and psychological climate, and this can result in full agreement and accord between theorists and artists. In the last analysis, however, both are following impulses which, for the most part, lie beyond rational explanation.

The inner evolution of style is reflected in changes in thought, poetry, art, and aesthetics. Styles sometimes reappear after an interval of many decades, even of centuries. Such recurrences may be caused by crises, like the wave of anti-naturalistic art at the beginning of the 20th century which began with something like a spiritual earthquake.[17] Yet reappearances of a particular style cannot merely be

explained as the result of "imitation" or "influences".[18] Moreover, a renewal of earlier aesthetic standards does not imply the repetition of the earlier art forms, despite the fact that they both spring from similar sources. With the same fundamental ideas as a starting point, the newer art movement may take different directions or realize different possibilities. The rebirth of classical forms or the re-emergence of Mannerist or Romantic thought must be understood primarily as the return of a certain psychological climate. Whenever, for example, Classicism enjoyed a new popularity, it meant that a certain generation was ready for its particular style, that at that very moment in history artists needed it, and that they found in the previous periods of Classicism a justification of their own efforts.

It is also important to realize that Classicism and Romanticism or Mannerism, can, and indeed do exist together at one and the same time, although one of them may in fact prevail. There are conflicting forces latent in the human soul, psychological potentialities which have often been expressed in contrasts: Classic and Romantic, tragic and comic, rational and irrational. These forces can develop, though separated by centuries, into a desire for clarity, regularity, and harmony, or into a love of the illogical, the irregular, the mystical. Furthermore, a certain balancing of these forces is possible, so that in some periods, and even in the work of some individuals, a series of contrasting styles can be observed.

One modern poet who recognized these tensions when he tried to find an explanation for the changing concepts of history was the Californian Robinson Jeffers, who once wrote: "This spiritual conflict creates strain in our psychology and in the heart of our culture". He called this tension

"spiritual war at the heart of our civilization". He sees a particular explanation for this phenomenon in the fact that "we still hold two sets of ethics, pagan and Christian, simultaneously". This description gives a deep insight into history, but the tension, the "civil war in us" goes even further back than Jeffers suggests. Greek aesthetes already knew the difference between what we call classical and anti-classical. They spoke of "mimesis" and "fantasia". Mimesis refers to art and poetry in which the visible and tangible world is recognized, fantasia to art and poetry which are concerned with the artist's invisible, imaginary world. Both concepts come very close to Mannerist ideas. The Mannerist concept of "disegno esterno" would appear to correspond to mimesis, and "disegno interno" to fantasia. In fact Mannerist ideas have their origin in Antiquity too. But it is to the anti-classical tradition in Antiquity, to the oriental occultists and mystics—in whose work Orphic dogma, Hebrew philosophy, and the rites and cults of Ancient Egypt lingered on—that one must turn in the search for the origin of Mannerism.

Yet, even if the Classic-Mannerist conflict in art and aesthetics was part of Western heritage long before Christ, Jeffers's formulations still have significance. It was inevitable that this centuries-old dissension, this "psychological civil war" assumed certain features of Christian philosophy and ethics, which left their mark in art and art theories.

It is hoped that this essay has shown that whether they belong to our century or to earlier periods, art theories are distinct manifestations of our own psychological potentialities. Like art itself, they are products of the individual

sensibility. Yet in every individual ego the perennial self is present. Thus every individual aesthetic theory or judgment is the product both of the ego, which is individual and time-bound, and of what seem to be supra-individual and timeless qualities of the human mind.

Notes

[1] It was Professor Wittkower who once pointed to the relativity of the concept of Mannerism. He rightly said that we are using the terms "late Mannerism", "transitional style", and "early Baroque", only "faute de mieux".

[2] A landscape such as "The Flight into Egypt", painted a few years after 1600 by Annibale Carracci (Rome, Galleria Doria-Pamphili), must have impressed, if not influenced, Poussin.

[3] J. A. Westrup, "Monteverdi and the Orchestra", in *Music and Letters* (1940).

[4] A. Rosenthal, "A hitherto unpublished letter of Claudio Monteverdi. Essays presented to Egon Wellesz". Ed. J. A. Westrup, Oxford, 1966.

[5] Cf. Virgil, Aeneid, Book VI, 140/1. In order to descend to the underworld, he needs the help of a golden branch.

[6] The violent controversy over Caravaggio was also going on in Spain. Vincenzio Carducho (1576–1638), who considered art to be a vehicle for moral and religious teaching, hated Caravaggio, "... this monster of genius and talent", who, despite his genius, just copied the model posing before him.

[7] Actually Angélique was not passing comment on Colbert's academic rules: she was protesting against an obsolete system that forced young women into loveless marriages. Molière, "Le Malade Imaginaire", Act II, Scene 6.

[8] This comes very close to what Moholy-Nagy wrote, more than a century later, in his handbook: "It is not the landscape or still-life that results in art, but the creative act by which the subject matter is transmuted into visual form".

[9] Many books on aesthetics were written between the time of Hegel and the turn of the 20th century when Croce wrote about the psychology and philosophy of seeing, and Wölfflin established new concepts of art history. However, the revolution in the arts had little to do with these excellent, scholarly books. The artists themselves took matters into their own hands, and began to proclaim their ideas in countless manifestos.

[10] Cf. Maurizio Fagiolo Dell'Arco, "Balla's Prophecies", *Art International*, XII/6.

[11] Apollinaire even banned the "logic" of a harmonious setting of the printed page, and developed, followed by Picabia, a dynamic and bewildering set of various types, strewn haphazardly over the page.

[12] Cf. K. T. Parker, "Catalogue of the Collection of Drawings in the Ashmolean Museum", Vol. II, p. 466.

[13] Ingres, whose art epitomized Classicism, was not at all free from Romantic influences in his youth. A remarkable example of this is the painting "The Dream of Ossian" of 1813.

[14] The Bibliothèque Nationale in Paris filled a long felt gap with its highly instructive exhibition "Quelques ancêtres du Surréalisme", graphic works from Raphael to Redon.

[15] T. S. Eliot, "The Metaphysical Poets", reprinted in "Selected Essays", London, 1953.

[16] Erich Heller (North Western University), "T. S. Eliot, Die Tradition und das Moderne", Avantgarde ... Munich, 1965.

[17] Although "The Waste Land" is one of the most important modern poems, Eliot – unlike the Futurists, Dadaists, and Surrealists – never complety severed all connection with the past. Picasso, like Eliot, has never rejected the great art of the past. He admires Corot, and even indulges in variations on paintings by such masters as Velasquez, Delacroix, Manet, and Cranach.

[18] Influences can, of course, play a part. Certain events can act as mediators. There is, for example, no doubt that the Armory Show of 1913 in New York, with its huge display of modern French art, had a great impact on American art. However, it should be remembered that American artists were prepared for such an influence, and that to a certain extent they had already advanced in a similar direction. Thus the Armory Show was more of a confirmation than a revelation. It is the same story with the "rapprochement" of French artists to the "School of New York" after World War II. The French artists would have refused this influence had they not begun to strive for a similar art expression.

A Biographical Note

The art historian Erwin Rosenthal (1889–1981) was born into one of the most important bookselling dynasties in Europe and married into another. The firms of Jacques Rosenthal in Munich and Leo Olschki in Florence bestrode the trade: Rosenthal issued around one hundred catalogues between 1895 and 1940. Jacques's only son, Erwin, worked on a series of five catalogues, published in 1914, on illustrated books of the fifteenth to the nineteenth centuries. He completed his doctoral thesis on the origins of woodcut illustration in Ulm in 1912 and the same year married Margherita Olschki, Leo's daughter. His activities as a dealer in books, manuscripts, and graphics, first in Berlin where he briefly ran a graphics gallery and later in Lugano and Zurich, ran parallel with his art-historical research; his major monograph on Giotto and the intellectual development of the Middle Ages was published in Augsburg in 1924. A contribution on Poussin was included in a Festschrift for the fiftieth birthday of the writer and art historian Wilhelm Hausenstein, a close family friend, in 1932.

With the rise of National Socialism and the danger to Jews, Erwin and Margherita emigrated to America in 1941. They had spent the five previous years in Italy, France, and Switzerland and, during the war years, lived in New York and Berkeley, where the business continued. It was during this American period that Erwin's contacts with leading collectors broadened to include Lessing Rosenwald, whose medieval miniature collection—later donated to the National Gallery of Art in Washington—he helped to build; and Igor Stravinsky, whom he advised, not least on appraising his manuscripts for the IRS. Erwin's correspondence with the redoubtable trio

of Stravinsky, Gertrud Schoenberg, and Alma Mahler still exists. In November 1948, Erwin organized from the United States an auction in Zurich that included Berg's *Wozzeck*, Mahler's Ninth Symphony, *Das Lied von der Erde*, and the first version of Bruckner's Third Symphony as well as the full score of Stravinsky's *Petrouchka*.

It is striking that Erwin's last art-historical publications, dating from after his return to Europe in 1958 but published in New York, deal with modern art, when he himself was in his eighties (with the exception of his last monograph, on the illuminations of the Vergilius Romanus manuscript, published in Zurich in 1972). In America he also became a playwright—creativity and modernity being the doppelgänger touchstones of his multifaceted long life: the discovery of Bridget Riley's work was a damascene moment. Erwin straddled the Old and New Worlds with profound intellectual engagement, clarity, enterprise, and a myriad of qualities, distilled in the following dedication to him by the Swiss illustrator Charles Hug in his edition of Flaubert's *L'Education Sentimentale*, that recalls an evening in August 1947:

> "Il n'y a pas longtemps
> depuis les ombres—mais
> il y a toujours de la lumière qui nous guide à aimer
> devoir et travail, à respecter les valeurs humaines, à
> créer le 'vrai.'"

"It has not been long since the shadows of war—but there is always light to guide us to love duty and work, to respect human values, to create 'truth.'"

Julia Rosenthal
Oxford and London
June 2012

Illustrations

97

PLATE VIII

Fig. 13. Klee, Paul, "Mask of Fear". Collection Dr. Allen Roos, New York.
Fig. 14. Chirico, Giorgio di, "Melancholy and Mystery of a Street", 1914.

PLATE IX

Fig. 15. Balthus, "The Room", ca. 1950. From Catalogue Arts Council, 1968.
Fig. 16. Delvaux, Paul, "Nu au mannequin".

PLATE X

Fig. 17. Moore, Henry, "Mother and Child", wood, 1938. (After Neumann.)
Fig. 18. The Great Mother, Reliefs in Limestone, France, Neolithic period. (After Neumann.)

PLATE XI

Fig. 19. Wenzel Jamnitzer, Polyhedric Construction.
Fig. 20. Bracelli, Engraving from "Bizzarrerie", Florence, 1624.

PLATE XII

Fig. 21. Vasarely, Victor, Exhibition Room, Paris, 1964.
Fig. 22. Agam, Yaacov, "Double Metamorphosis II", 1964. From "The Responsive Eye", Catalogue of the Museum of Modern Art, New York, 1965.

PLATE XIII

Fig. 23. Equipo 57, "V. 25", Engraving on glass, 1964.
Fig. 24. Riley, Bridget, "Hesitate", Larry Aldrich Museum, Conn.

PLATE XIV

Fig. 25. Duchamp, Marcel, "Rotary Glass Plate" (Precision Optics), 1920, New Haven University Art Gallery.
Fig. 26. Tadasky, "A 101", Oil on canvas, 1964. From "The Responsive Eye", Catalogue Museum of Modern Art, New York, 1965.

PLATE XV

Fig. 27. Gabo, Naum, "Double Metamorphosis II", ca. 1950.
Fig. 28. Vardanega, Gregorio, "Monde de Transparence", plexiglas,

1960 (inside movable). From Catalogue, Gimpel Hanover Gallery, Zurich, 1964.

PLATE XVI

Fig. 29. Linck, Walter, "Animated Harp".
Fig. 30. Sobrino, Francisco, "Unstable Transformation", plexiglas. Gallery Denise René, Paris.

PLATE XVII

Fig. 31. El Greco, "Laocoon", 1610. Washington, National Gallery.
Fig. 32. Mansù, Desiderio, "Le Silence", Collection Ed. Bloch, Rome.

PLATE XVIII

Fig. 33. Carracci, Annibale, "Polyphemus", 1597–1604, Rome, Farnese Gallery.
Fig. 34. Carracci, Annibale, "Flight into Egypt", ca. 1604, Rome, Galleria Doria Pamphili.

PLATE XIX

Fig. 35. Raphael, "The Triumph of Galatea", Fresco, ca. 1514, Rome, Villa Farnesina.
Fig. 36. Poussin, Nicolas, "The Triumph of Neptune and Amphitrite", ca. 1637, The Pennsylvania Museum of Art, Philadelphia.

PLATE XX

Fig. 37. Reni, Guido, "Attalanta and Hippomenes", Galleria Nazionale di Capodimonte, Naples.

PLATE XXI

Fig. 38. Poussin, Nicolas, "Sleeping Venus", Kunsthaus, Zurich. – The composition dates from 1631–33, whereas some experts don't believe that the painting was finished by the master himself. – My thanks go to the direction of the Zurich Kunsthaus for supplying me with the Museum's photograph.

PLATE XXII

Fig. 39. Caravaggio, "Conversion of St. Paul", Rome, S. Maria del Popolo.
Fig. 40. Le Nain, Louis, "Peasants in front of a rural house", Boston, Museum of Fine Arts.

PLATE XXIII

Fig. 41. Blake, William, Illustration for "Revelation XII", ca. 1805, Washington, National Gallery.
Fig. 42. Fuseli, Henry, "The Nightmare", Detroit, Institute of Arts.

PLATE XXIV

Fig. 43. Ernst, Max, "Joy of Life", 1936.

PLATE XXV

Fig. 44. Ernst, Max, "The Paradise", ca. 1940.
Fig. 45. Magritte, René, "Les marches de l'été", 1938.

PLATES

PLATE I

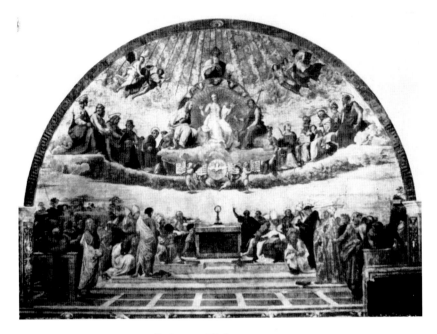

Fig. 1. Raphael, "Disputa", Rome, Vatican.

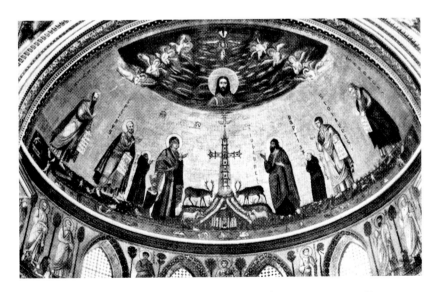

Fig. 2. Torriti, Jacopo, Apsidal Mosaic, late 13th century, Rome, Lateran.

PLATE II

Fig. 3

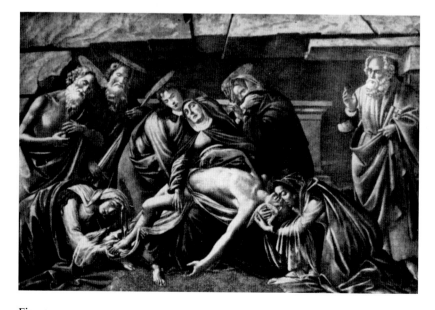

Fig. 4

PLATE III

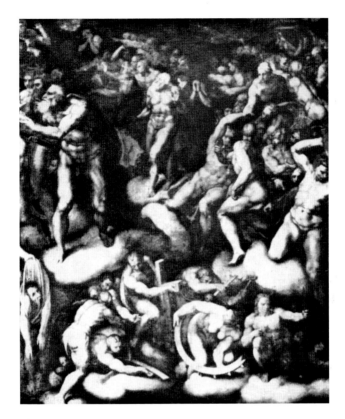

Fig. 5

Fig. 3. Potormo, Jacopo, "Deposition of Christ", Florence,
Santa Felicita.

Fig. 4. Botticelli, Sandro, "Lamentation of Christ", Munich,
Alte Pinakothek.

Fig. 5. Michelangelo, "Last Judgment". Marcello Venusti's
copy of 1549, before Volterra's alterations. Naples, Mus.
di Capodimonte. (After Wittkower.)

PLATE IV

Fig. 6. Malevitch, Kasimir, "Yellow, Orange, Green", ca. 1914.

Fig. 7. Larionov, Michael, "Night of May", ca. 1911. © 2013
Artists Rights Society (ARS), New York/ADAGP, Paris.

PLATE V

Fig. 8. Brancusi, Constantin, "The Bird", 1933-1937, Bronze. Coll. Peggy Guggenheim, Venice. © 2013 Artists Rights Society (ARS), New York/ADAGP, Paris.

Fig. 9. Bill, Max, "Endless loop from a ring II", gilt brass, 1947-49. © 2013 © 2013 Artists Rights Society (ARS), New York/ProLitteris, Zurich.

PLATE VI

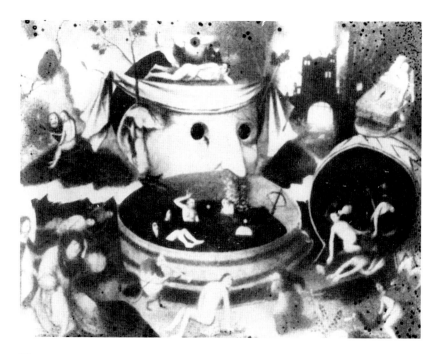

Fig. 10

Fig. 10. School of Hieronymus Bosch, Detail.
Fig. 11. Dali, Salvador, "Galatea in formation". © Salvador
 Dali, Fundació Gala-Salvador Dali, Artists Rights
 Society (ARS), New York, 2013.
Fig. 12. Arcimboldi, "Homo omnis creatura".

PLATE VII

Fig. 11

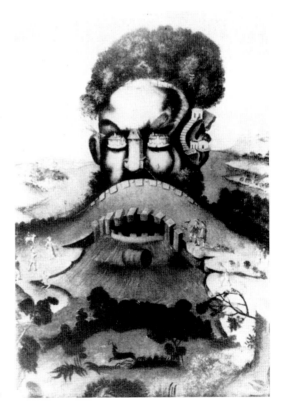

Fig. 12

PLATE VIII

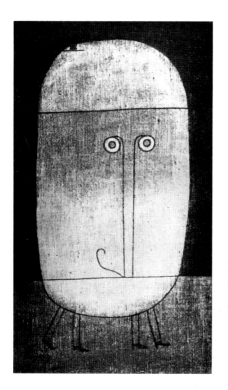

Fig. 13. Klee, Paul, "Mask of Fear". Collection Dr. Allen Roos, New York. © 2013 Artists Rights Society (ARS), New York.

Fig. 14. Chirico, Giorgio di, "Melancholy and Mystery of a Street", 1914. © 2013 Artists Rights Society (ARS), New York/SIAE, Rome.

PLATE IX

Fig. 16. Delvaux, Paul, "Nu au mannequin". © 2013 Artists
Rights Society (ARS), New York/SABAM, Brussells.

PLATE X

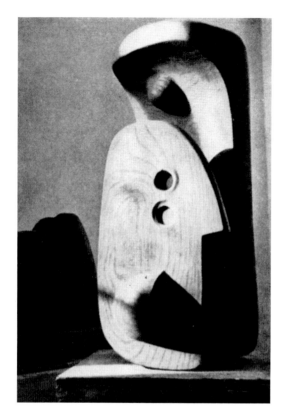

Fig. 17. Moore, Henry, "Mother and Child",
wood, 1938. Reproduced with permission of the
Henry Moore Foundation.

Fig. 18. The Great Mother, Reliefs in Lime-
stone, France, Neolithic period.

PLATE XI

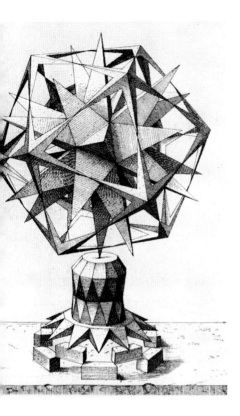

Fig. 19. Jamnitzer, Wenzel,
Polyhedric Construction.

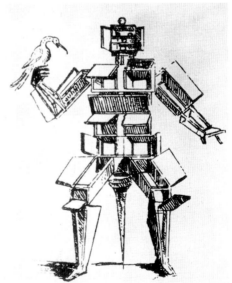

Fig. 20. Bracelli, Engraving from
"Bizzarrerie", Florence, 1624.

PLATE XII

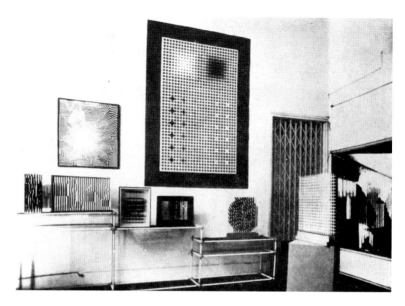

Fig. 21. Vasarely, Victor, Exhibition Room, Paris, 1964. © 2013 Artists Rights Society (ARS), New York/ADAGP, Paris.

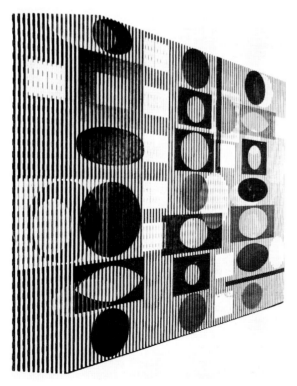

Fig. 22. Agam, Yaacov, "Double Metamorphosis II", 1964. © 2013 Artists Rights Society (ARS), New York/ADAGP, Paris.

PLATE XIII

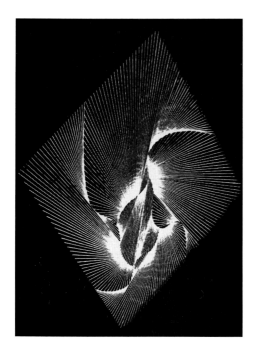

Fig. 23. Equipo 57, "V. 25", Engraving on glass, 1964.

Fig. 24. Riley, Bridget, "Hesitate", © Bridget
Riley 2013. All rights reserved, courtesy Karsten
Schubert, London2, and the artist.

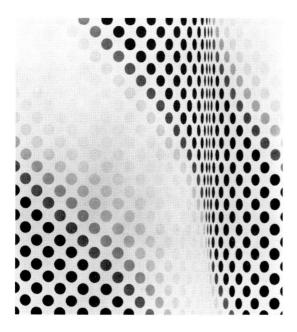

PLATE XIV

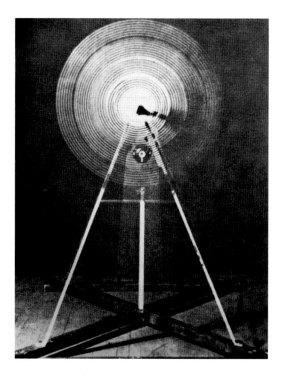

Fig. 25. Duchamp, Marcel, "Rotary Demispssere" (Precision Optics) 1920, New Haven Univ. Art Gallery. © succession Marcel Duchamp/ ADAGP, Paris/Artists Rights Society (ARS), New York, 2013.

Fig. 26. Tadasky, "A 101", Oil on canvas, 1964. © Tadasky (Tadusuke Kuwayama). Used by permission of the artist.

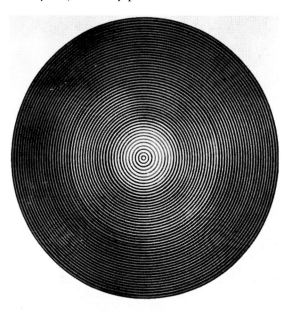

PLATE XV

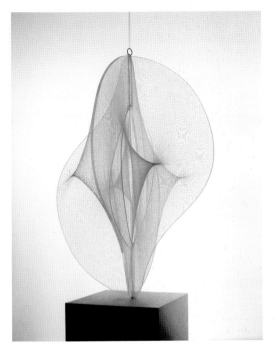

Fig. 27. Gabo, Naum, "Linear No. 2", ca. 1950. © Tate, London, 2013.

Fig. 28. Vardanega, Gregorio, "Monde de Transparence", plexiglas, 1960. © 2013 Artists Rights Society (ARS), New York/ADAGP, Paris.

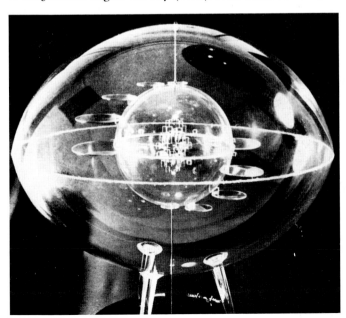

Plate XVI

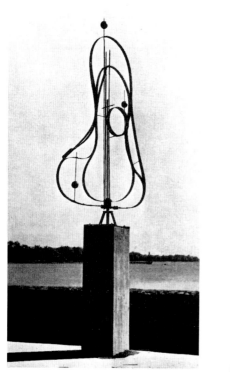

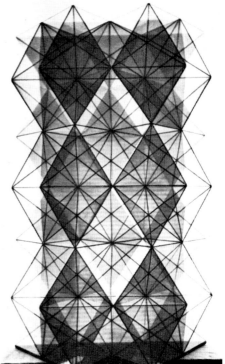

Fig. 29

Fig. 30

Fig. 29. Linck, Walter, "Animated Harp".

Fig. 30. Sobrino Ochoa, Francisco, "Unstable Transformation",
plexiglas. Gall. Denise René, Paris. © 2013 Artists Rights
Society (ARS), New York/VEGAP, Madrid.

PLATE XVII

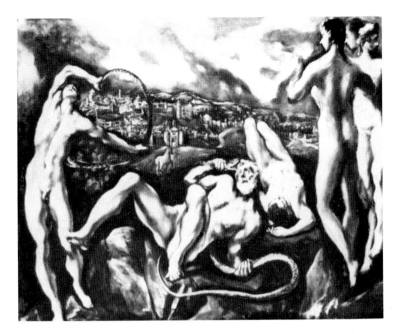

Fig. 31. El Greco, "Laocoon", 1610, Washington, National Gallery.

Fig. 32. Monsù, Desiderio, "Le Silence", Coll. Ed. Bloch, Rome.

PLATE XVIII

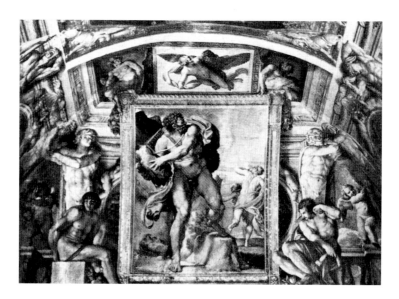

Fig. 33

Fig. 34

Fig. 33. Carracci, Annibale, "Polyphemus", 1597-1604, Rome, Farnese Gallery.

Fig. 34. Carracci, Annibale, "Flight into Egypt", ca. 1604, Rome, Gall. Doria Pamphili.

Fig. 35. Raphael, "The Triumph of Galatea", Fresco, ca. 1514, Rome, Villa Farnesina.

Fig. 36. Poussin, Nicolas, "The Triumph of Neptune and Amphitrite", ca. 1637, The Pennsylvania Mus. of Art, Philadelphia.

PLATE XIX

Fig. 35

Fig. 36

PLATE XX

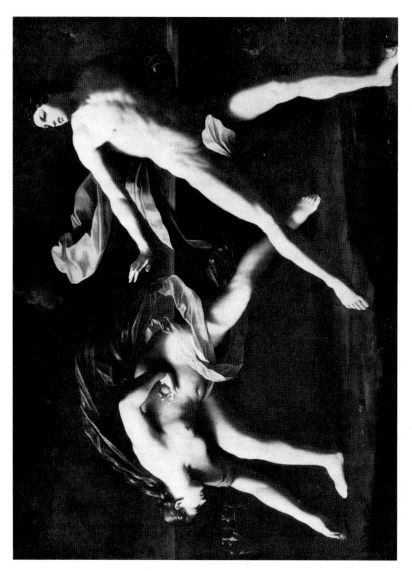

Fig. 37. Reni, Guido, "Attalanta and Hippomenes", Gall. Nazionale di Capodimonte, Naples.

PLATE XXI

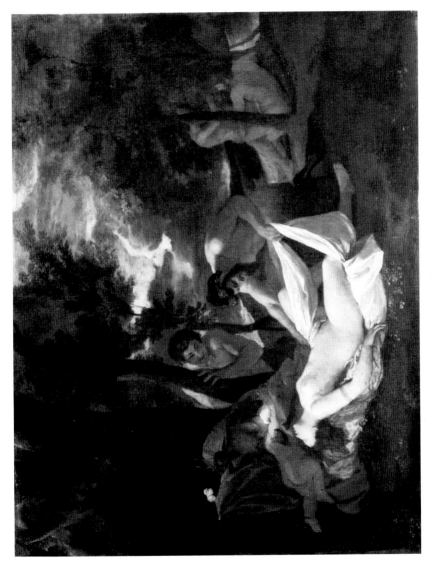

Fig. 38. Poussin, Nicolas, "Sleeping Venus". Kunsthaus, Zürich.

PLATE XXII

Fig. 39. Caravaggio, "Conversion of St. Paul", Rome S. Maria del Popolo.

Fig. 40. Le Nain, Louis, "Peasants in front of a rural house", Boston, Museum of Fine Arts.

PLATE XXIII

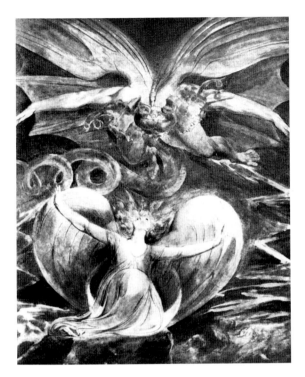

Fig. 41. Blake, William, Illustration for "Revelation XII." Ca. 1805. Washington, National Gallery.

Fig. 42. Fuseli, Henry, "The Nightmare", Detroit, Institute of Arts.

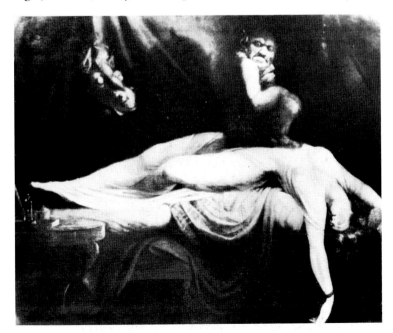

PLATE XXIV

Fig. 43

Fig. 43. Ernst, Max, "Joy of Life", 1936. © 2013
Artists Rights Society (ARS), New York/
ADAGP, Paris.

Fig. 44. Ernst, Max, "The Paradise", ca. 1940. © 2013
Artists Rights Society (ARS), New York/
ADAGP, Paris.

Fig. 45. Magritte, René, "Les marches de l'été", 1938.
© 2013 C. Herscovici, London/Artists Rights
Society (ARS), New York.

PLATE XXV

Fig. 44

Fig. 45

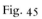

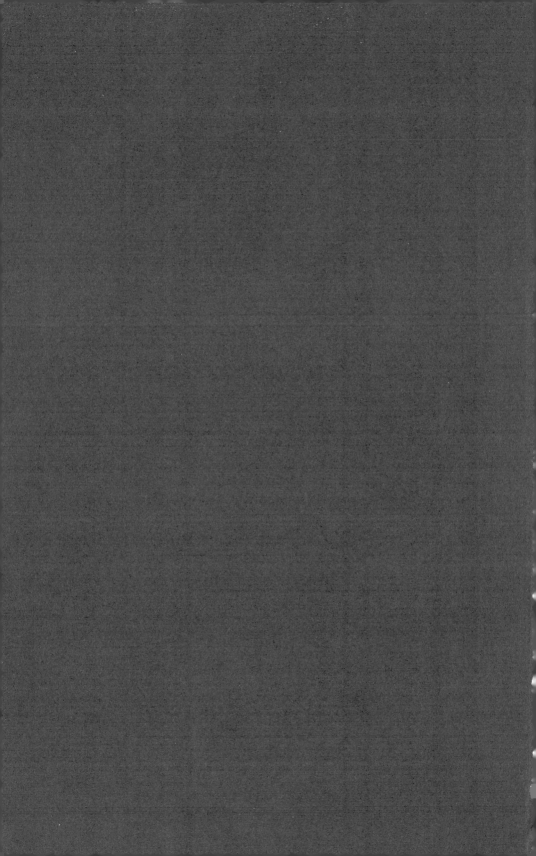